CREATIVE
DRAWING

For Leo Johann

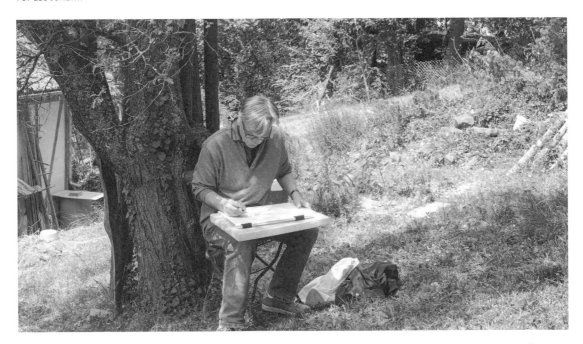

CREATIVE
DRAWING

100 Tips to Expand your Talent

Albrecht Rissler

 HOAKI

■ **CREATIVE DRAWING** isn't a textbook that you have to work through systematically. With this richly illustrated book, you can get started wherever you want. Above all, there are over 100 tips to help you enjoy finding out what drawing can mean.

I wrote it for beginners as well as for advanced illustrators. It is also aimed at people who don't draw, but still enjoy the oldest of all the arts. I'm sure there are some people who remember how much they loved drawing during their childhood and want to get back into it again.

Along with the drawing techniques, you will find notes and photos of the materials used. The fact that this book doesn't push any particular type of drawing style can be seen in the selection of artwork by students, whom I was allowed to supervise at the Mainz University of Applied Sciences and who accompanied me on numerous drawing excursions. This includes some examples by participants of my drawing classes and by fellow colleagues. The book can also be seen as an appeal to artists, designers and architects not to neglect the all-engrossing analogue technique that is drawing.

The Urban Sketchers – who represent a growing scene worldwide – demonstrate with their sketchbooks just how attractive drawing in situ has become

again. In the book, you will also find artwork done by children. These remind me of the responsibility that parents and teachers have in encouraging children's visual skills. These skills are a prerequisite for any kind of creativity, and are important in cognitive areas, too.

My thanks go to all who contributed to the success of this book. I thank the publisher Gerhard Rossbach, the editor Barbara Lauer and all employees at dpunkt. verlag publishers for their enthusiasm for this project. Without the support of my wife Ursula, the book would not have been written. Her eye for good design and her help in writing the words proved to be very helpful during this time. On behalf of many others, I also thank Dr. Markus Käfer and Heiko Ernst for their invaluable hints and suggestions. I am particularly grateful to former students, participants of my drawing courses, fellow artists and the children who provided artwork for this book.

Albrecht Rissler, May 2015

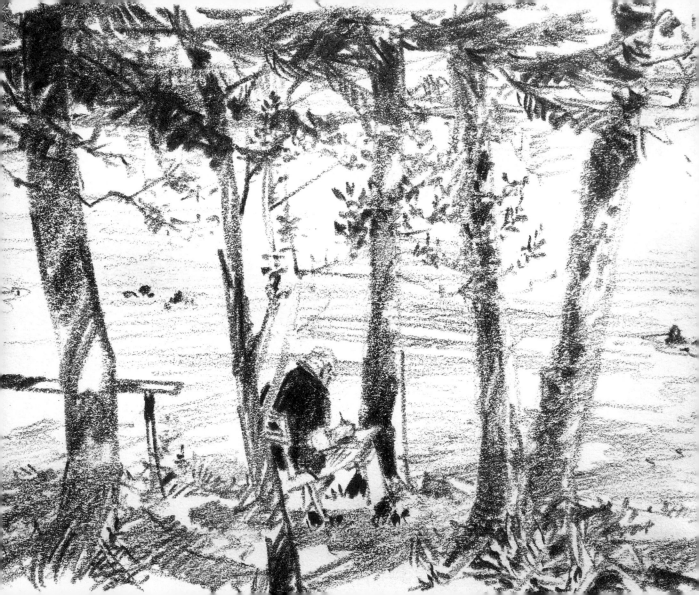

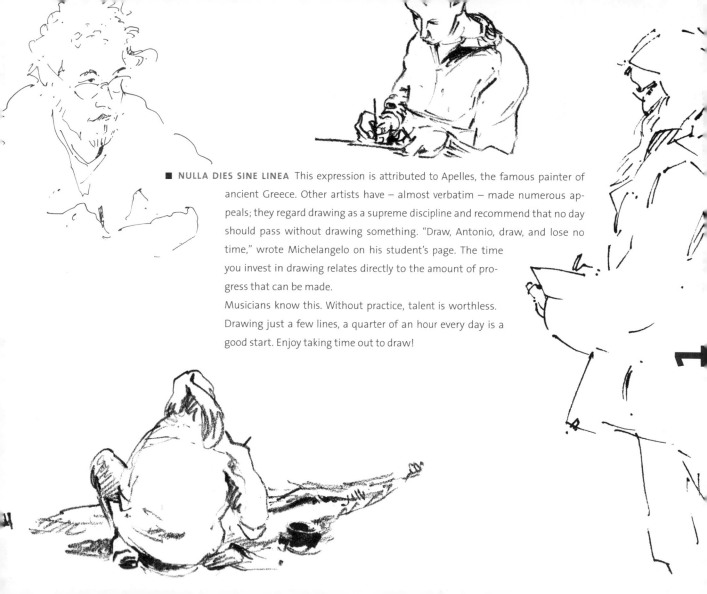

■ **NULLA DIES SINE LINEA** This expression is attributed to Apelles, the famous painter of ancient Greece. Other artists have – almost verbatim – made numerous appeals; they regard drawing as a supreme discipline and recommend that no day should pass without drawing something. "Draw, Antonio, draw, and lose no time," wrote Michelangelo on his student's page. The time you invest in drawing relates directly to the amount of progress that can be made.

Musicians know this. Without practice, talent is worthless. Drawing just a few lines, a quarter of an hour every day is a good start. Enjoy taking time out to draw!

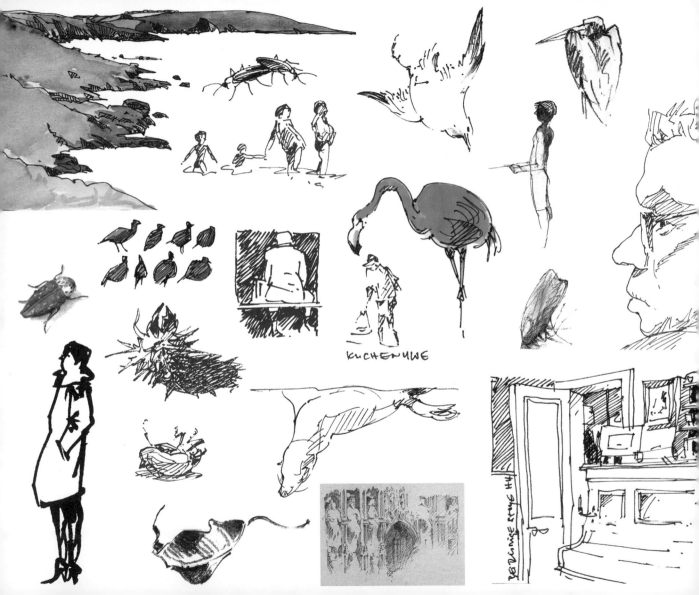

KUCHENUWE

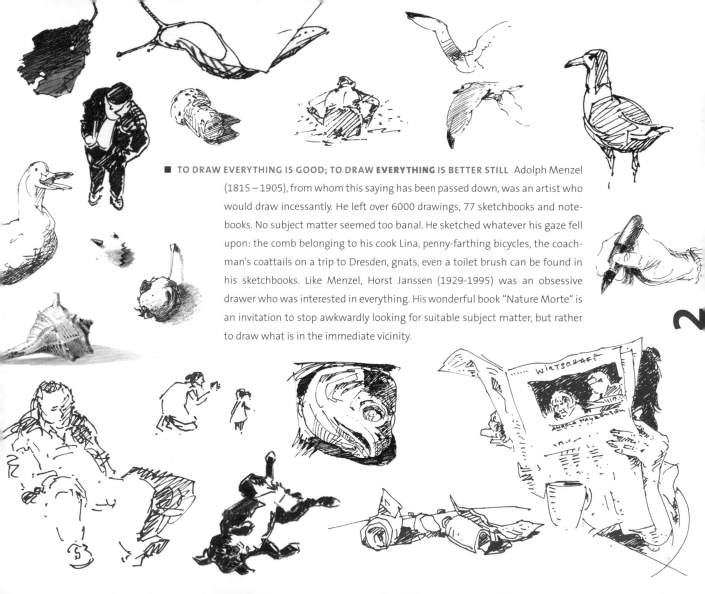

■ TO DRAW EVERYTHING IS GOOD; TO DRAW EVERYTHING IS BETTER STILL Adolph Menzel (1815 – 1905), from whom this saying has been passed down, was an artist who would draw incessantly. He left over 6000 drawings, 77 sketchbooks and note-books. No subject matter seemed too banal. He sketched whatever his gaze fell upon: the comb belonging to his cook Lina, penny-farthing bicycles, the coach-man's coattails on a trip to Dresden, gnats, even a toilet brush can be found in his sketchbooks. Like Menzel, Horst Janssen (1929-1995) was an obsessive drawer who was interested in everything. His wonderful book "Nature Morte" is an invitation to stop awkwardly looking for suitable subject matter, but rather to draw what is in the immediate vicinity.

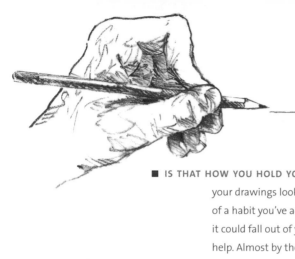

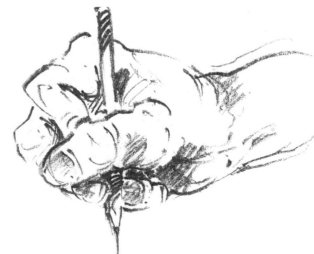

■ **IS THAT HOW YOU HOLD YOUR PEN?** Attention! That could be one of the reasons why your drawings look stiff and not very spontaneous. I know, you can't just get rid of a habit you've acquired over the years. But still, try to hold the pen as though it could fall out of your hand at any time. Thick, heavy drawing instruments will help. Almost by their weight alone, they leave a mark using hardly any pressure at all. And don't put your palm down when you're drawing. If need be, rest your little finger on the paper for support and guidance. Even better, try drawing upright at an easel now and then. All of this nurtures expressive drawing and trains the motor skills of your hand at the same time.

3

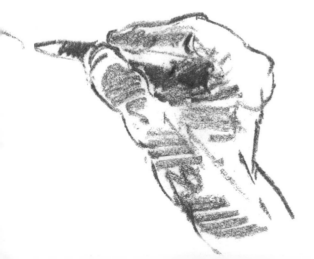

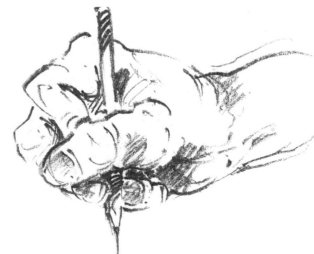

■ **USE THE RIGHT TOOLS FROM THE START** Of course, anything with ink, graphite, charcoal or any other kind of colouring substance is suitable for drawing. Picasso led the way with this. He's thought to have drawn on tablecloths even. Nevertheless, the quality of a drawing also depends on the quality of the materials used. Paper that is too thin or not fastened down, pencils that break, blunt sharpeners, dry felt-tip pens and rubber erasers that smear can cause a great deal of frustration. Sketchbooks that get tatty after a while are a nuisance. When selling or giving away your work, keep in mind the lightfastness of the paper, the pens and paints used. It's embarrassing to get a piece of work held under your nose after a few years, where the paper has changed colour or the colour has disappeared from the drawing completely, like a secret code. It would be a pity if a beautiful drawing wasn't preserved for posterity.

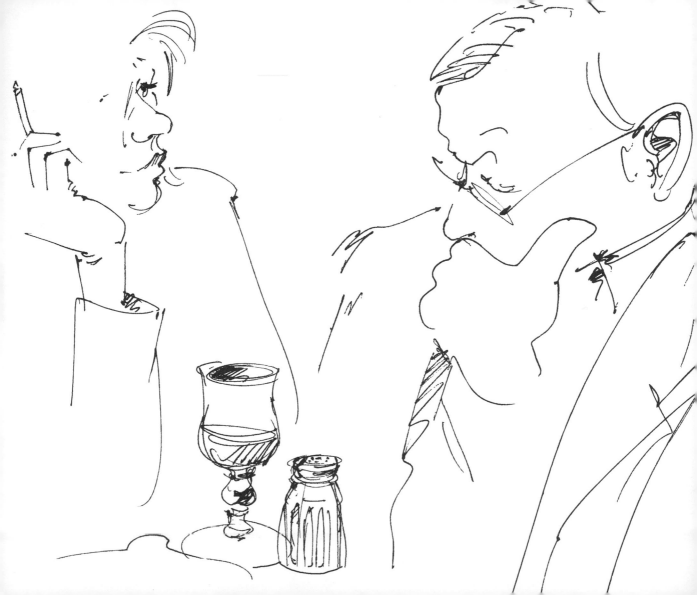

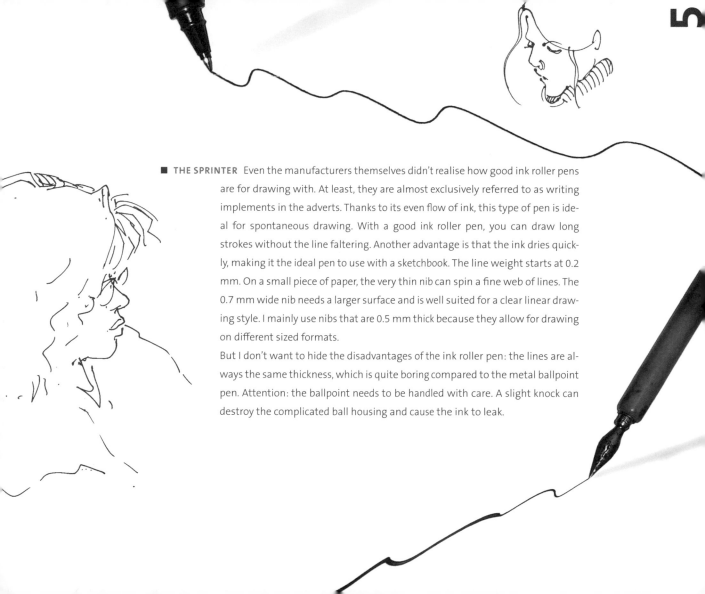

■ THE SPRINTER Even the manufacturers themselves didn't realise how good ink roller pens are for drawing with. At least, they are almost exclusively referred to as writing implements in the adverts. Thanks to its even flow of ink, this type of pen is ideal for spontaneous drawing. With a good ink roller pen, you can draw long strokes without the line faltering. Another advantage is that the ink dries quickly, making it the ideal pen to use with a sketchbook. The line weight starts at 0.2 mm. On a small piece of paper, the very thin nib can spin a fine web of lines. The 0.7 mm wide nib needs a larger surface and is well suited for a clear linear drawing style. I mainly use nibs that are 0.5 mm thick because they allow for drawing on different sized formats.

But I don't want to hide the disadvantages of the ink roller pen: the lines are always the same thickness, which is quite boring compared to the metal ballpoint pen. Attention: the ballpoint needs to be handled with care. A slight knock can destroy the complicated ball housing and cause the ink to leak.

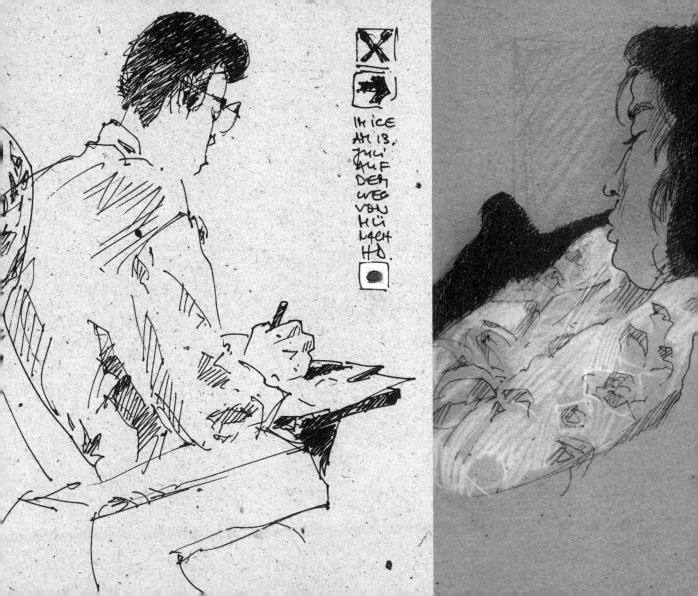

■ DRAWING ON A TRAIN If you daren't draw the person sitting directly opposite you on the train, you can put to paper images of sleeping passengers or those in the next row, as seen from the side or through a gap between the seats. It is quite possible that you will be discovered. With a friendly smile at your „model", you can usually smooth out any annoyance they might feel. Photographers do this too. While the train is sitting in the station is a great time for making some quick sketches of the people waiting outside on the platform.

This sort of sketch works best with a heavyweight ink roller pen. It has a clear stroke and only needs a small amount of pressure to work. This is important if you want to quickly draw people who are moving.

If you pick up your sketchbook again in a few years' time and look at the drawings of the passengers, you'll be glad if you've also noted down the route, the time and the type of train. This helps you to remember more than just what you've put in the drawing.

■ **REPEAT YOURSELF!** Being able to play an instrument means you are familiar with it: if you want to rehearse specific notes, you wouldn't give up and play another piece of music the minute you hit a bum note. You'd probably play it until you can master it.

I can only offer you the same advice if you want to draw an object. Don't give up on the first attempt. You will see, with each sketch, the subject matter becomes more and more familiar. You won't like each new attempt any more than the first one. That's normal. Hang the first attempt somewhere you can see it, with the most recent one beside it. This helps you to keep an eye on what has changed. After a few dozen drawings, you'll be able to see the progress. I promise!

An extra tip for those of you applying to university: getting your teeth into drawing an object, attacking it from all sides and presenting it in ever new variations, goes down well with university portfolio assessors! See also tip 107.

■ DRAWING ON THE MOVE Getting someone else to drive is a much smarter move. This remark from a colleague often comes to mind when I'm sitting behind the wheel. One thing's for sure: I would have done lots of drawings had I been relaxing with a sketchbook in the back seat. After a few years, I would be able to see who had driven me from A to B or what had been happening on either side of the road.

Stefan Gelberg's picture was drawn during a bus trip in Turkey. He will remember the men sitting at the front, still hear their voices or even remember what colour their jackets were. He'll probably still remember what the woman on the street looked like, her image captured by four strokes. Far-fetched? Absolutely not, because drawing is like having a marker that fixes perceptions in the brain. They are stored there until you pick up the sketchbook again. Be smart. Let someone else drive. Draw when you're in the car. Is it too bumpy? Well yes. But that's what's so good about it!

■ **SEE IT THROUGH** The thumb and index finger of both hands form a square. The gap in the middle sets the focus of the subject matter. It's perhaps more practical to use a cardboard frame, with the proportions of the paper you're drawing on, or two nested angles that slide open, which you hold in front of you at a suitable distance. These are traditional tools that can be used to roughly determine the details in your picture.

But this doesn't allow you to record the section you've selected. It's easier with a digital camera. Variations can be saved and compared. The best solution becomes obvious. And: with a digital camera and its frame-mounted display, you can start to get a feel for good composition everywhere you go. It's always there anyway. See also tips 10, 54 and 59.

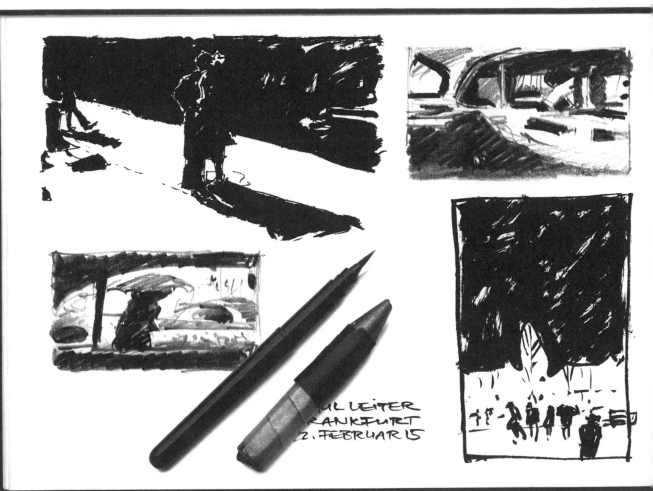

PAUL LEITER
FRANKFURT
22. FEBRUAR 15

■ **MEMORY TRACK** With a sensitive eye, photographer Saul Leiter (1923 – 2013) took a fascinating look at New York street life. His courageous shots demonstrate an exceptionally keen sense for exciting composition. His poetic colour photographs, which are reminiscent of Japanese woodblock prints, are the most appealing and the colours used are important components of the composition.

It's quite interesting to try to reduce Leiter's colour photos to greyscale. This makes it even clearer just how sure the photographer was about composition. He would masterfully and spontaneously (!) use exciting contrasts of texture and chiaroscuro, space-aligned perspectives, blocked foregrounds, multiple layers and scenes that looked like stage sets – especially using fogged up windows to get these effects.

Next time you visit a photo exhibition, take a sketchbook with you. Try to analyse compositionally interesting photos by drawing quick sketches. You will learn to understand the ideas behind good photography. What's more, you'll be surprised by what you discover. In your memory, you start to lay a track that shows you how to create exciting visual compositions, whether they're drawn or photographed. See tips 9, 54 and 59.

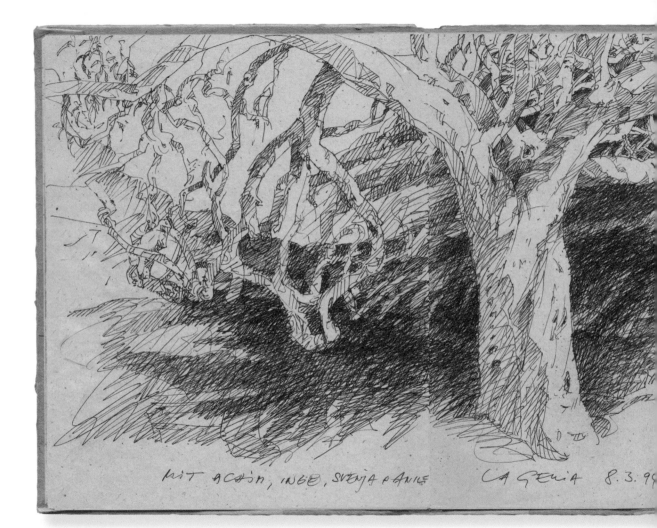

MIT ACÁIN, INGO, SVENJA PANIE LA GERIA 8.3.99

■ **LIKE A FAN** There are lots of ways to give a boring square some visual tension. Round patterns create a contrast with the design area. Sections in different sizes liven up the image format. Contrasts of light and dark give drawings an impactful effect, allowing you to forget their tedious square shape. Among the most effective are diagonals, especially when lines of various lengths are used to balance the pattern out. A variation on the diagonal design is to fan out some sections of the image. If you look at a cross-section of a tree, you can see that the diagonals coming out in all directions all reach the outer edges of the image, holding the pattern together. In a sketchbook, fanning contributes to the cohesion of the two sides.

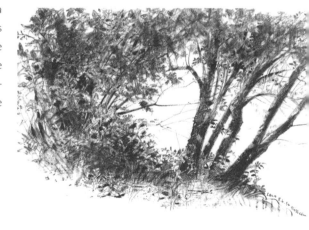

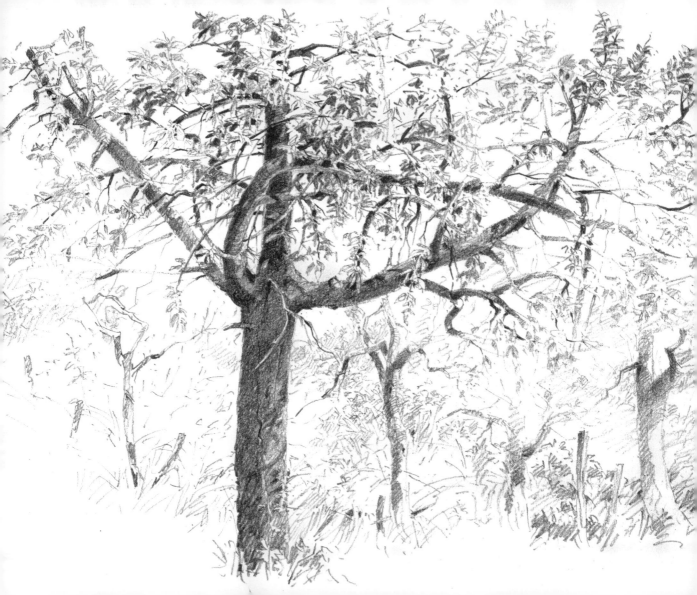

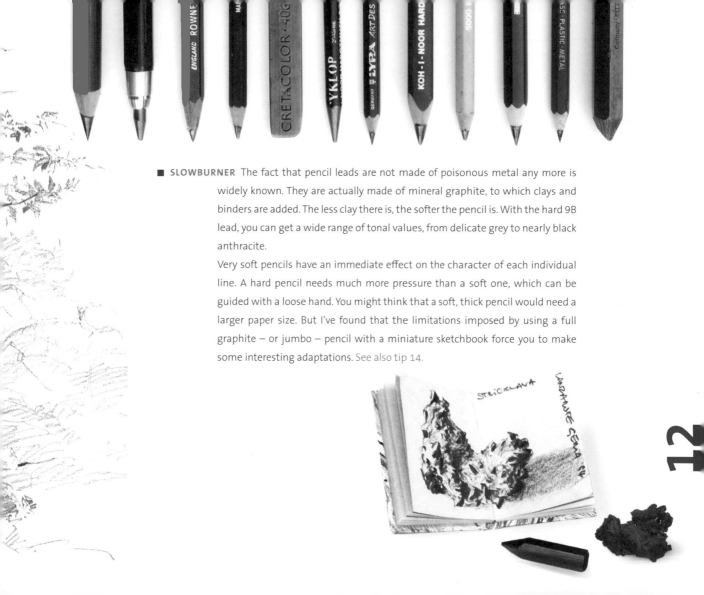

■ **SLOWBURNER** The fact that pencil leads are not made of poisonous metal any more is widely known. They are actually made of mineral graphite, to which clays and binders are added. The less clay there is, the softer the pencil is. With the hard 9B lead, you can get a wide range of tonal values, from delicate grey to nearly black anthracite.

Very soft pencils have an immediate effect on the character of each individual line. A hard pencil needs much more pressure than a soft one, which can be guided with a loose hand. You might think that a soft, thick pencil would need a larger paper size. But I've found that the limitations imposed by using a full graphite – or jumbo – pencil with a miniature sketchbook force you to make some interesting adaptations. See also tip 14.

12

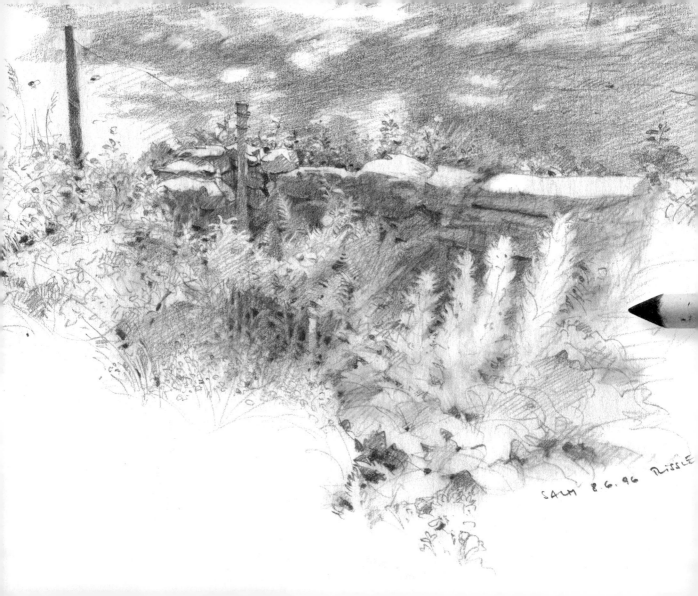

SALM 8.6.96 Rissle

SMUDGING IS FORBIDDEN! You've already heard that in an art class or drawing class, haven't you? Indeed, smudging graphite is rather frowned upon. It's true that shading like this can make drawings look a bit washed out, because the lines of the drawing disappear. The use of a paper wiper (estompe) is useful when you want to make delicate transitions between tonal values – like in the drawing of the flowering rhubarb on the left. If you want to smudge a pencil drawing, it's best to use graphite grades 8 or 9B. To make the artwork into a *drawing* again, a hatched layer or single lines can be drawn over the softly shaded surface.

The estompe is made out of wrapped up blotting paper. They come in various sizes, from 6 to 16 mm in diameter. This "smudge stick" can also be used with pastel chalks and charcoal. The tip of the paper wiper also works reasonably well with sandpaper.

13

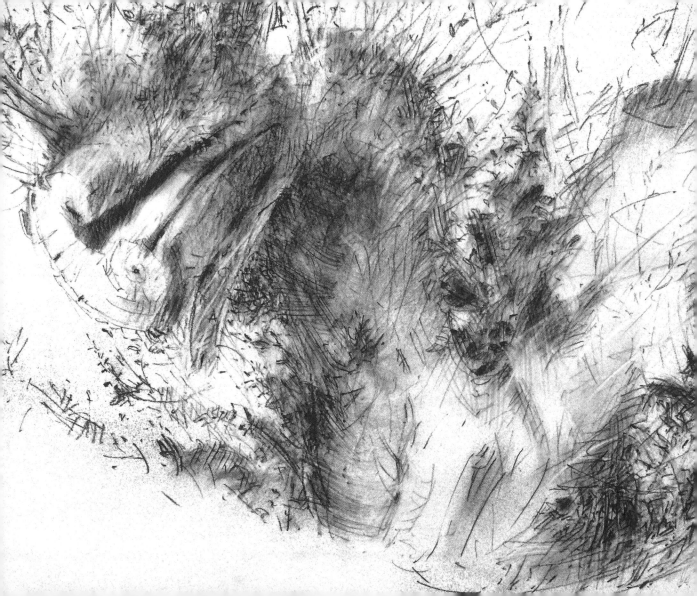

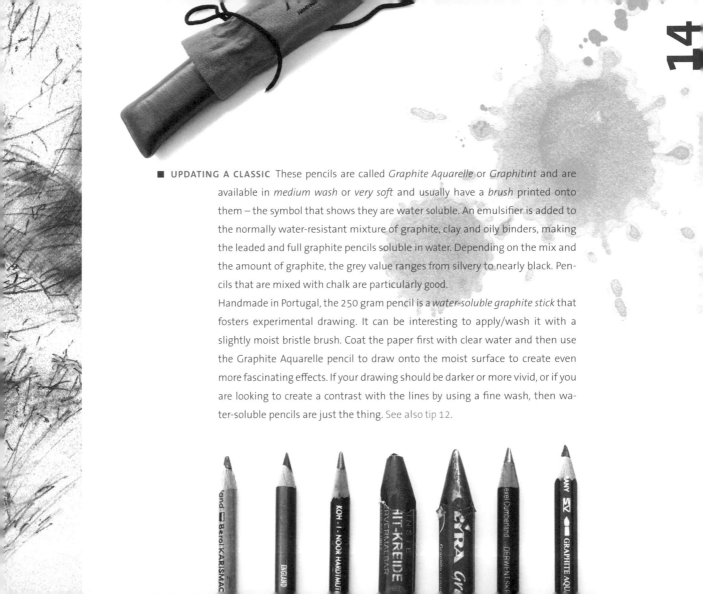

■ **UPDATING A CLASSIC** These pencils are called *Graphite Aquarelle* or *Graphitint* and are available in *medium wash* or *very soft* and usually have a *brush* printed onto them — the symbol that shows they are water soluble. An emulsifier is added to the normally water-resistant mixture of graphite, clay and oily binders, making the leaded and full graphite pencils soluble in water. Depending on the mix and the amount of graphite, the grey value ranges from silvery to nearly black. Pencils that are mixed with chalk are particularly good.

Handmade in Portugal, the 250 gram pencil is a *water-soluble graphite stick* that fosters experimental drawing. It can be interesting to apply/wash it with a slightly moist bristle brush. Coat the paper first with clear water and then use the Graphite Aquarelle pencil to draw onto the moist surface to create even more fascinating effects. If your drawing should be darker or more vivid, or if you are looking to create a contrast with the lines by using a fine wash, then water-soluble pencils are just the thing. See also tip 12.

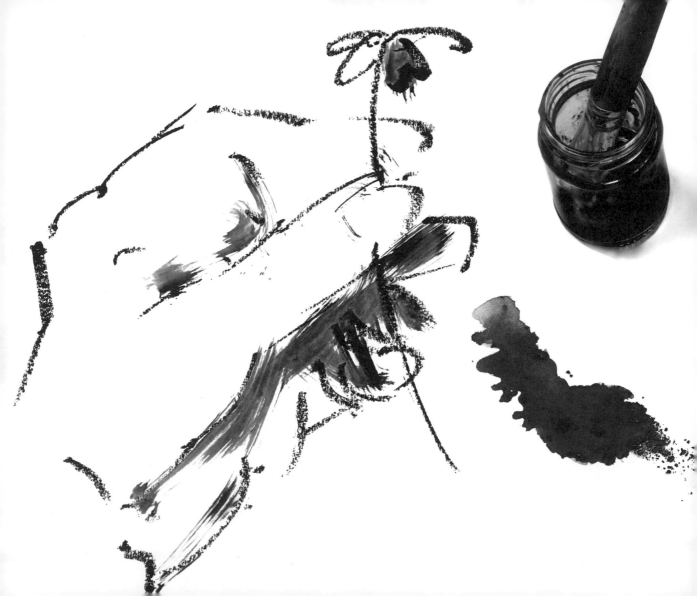

■ **FOR SPONTANEOUS PEOPLE** A model, thick oil pastels, bistre, smooth A4 paper, a glass of water, a rag and a broad bristle brush. That's all you need. Bistre is a pigment derived from wood ash. Its colour depends on the type of wood and is available as granules for mixing or ready-made.

Ask your model to take on different poses with their hands. Their quick position changes force you to draw swiftly with the oil crayon. Spontaneity takes precedence over correctness.

Oil pastels are quite unwieldy and are not suitable for precise drawing anyway. With the soot pigment and a brush, you can quickly colour in the areas you've just drawn. A slightly moistened bristle brush creates an interesting effect. If you also use smooth paper, it is easier to make the oil crayon pigment drip off. See also tip 32.

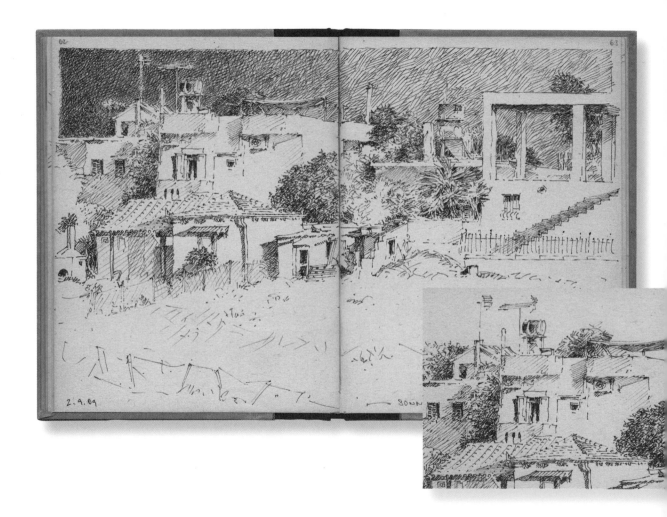

2.9.09

SONN

■ **AFTER – BEFORE** Daybreak in southern Crete. From the hotel balcony, I drew part of the nearby village. The sun quickly rose above the horizon, dipping the white buildings in a delicate shade of pink, while the sky was still tinged with midnight-blue. This is my memory of that morning.

As I picked up my sketchbook at home, I noticed that the mood of the drawing didn't quite match my memory. The houses have no contrast against the bright background. At best, you might be able to guess the time of day by looking at the shadows.

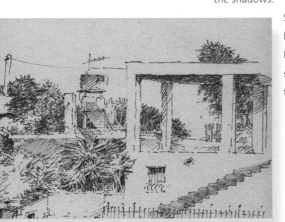

So I came up with the idea of giving the sky tonal value by using hatched lines that become increasingly dense from right to left. In this way, the buildings got the light they needed. This composition demonstrates what effect can be achieved with different tonal values. See also tip 17.

16

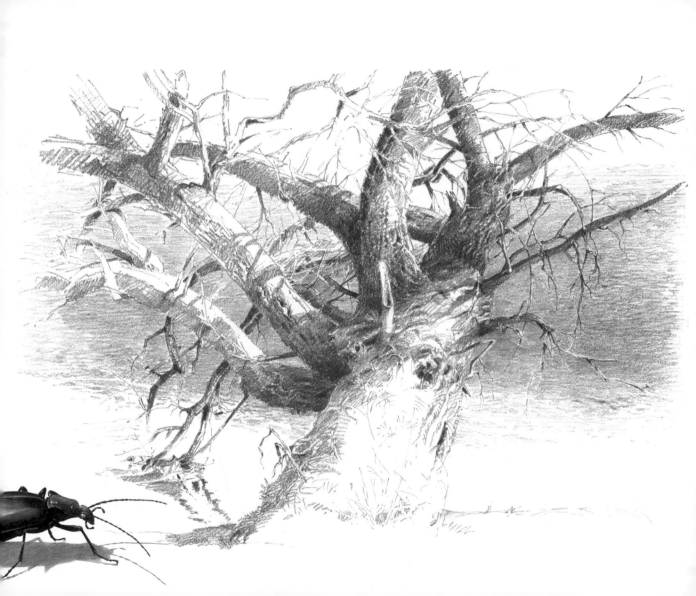

■ **SHADOWS CREATE LIGHT** The light catching the overhanging grass on a stretch of the Old Rhine only appeared when I drew the tonal value of the water. When using white paper, this is the only way to make something shine. Shadows can do so much more: when rounded, they can help to make the trunk and branches appear three-dimensional. Depending on whether the shadows bend upwards or downwards, they indicate the direction in which the branches stretch. Also, the darker you make it, the brighter the light becomes.

Just by adding a bit of shadow, a piece of drawing paper assumes three-dimensional space. Here, insects seem to crawl across a piece of paper. A light source located outside the paper illuminates it.

I advise you to always try to achieve this effect whenever the atmosphere in your artwork is important to you. Experiment with different tonal values. If you are worried about spoiling your work, make a copy of it so you can try out the effect of even darker shadows on top. It will make you even braver when you do your next original drawing. See also tip 16.

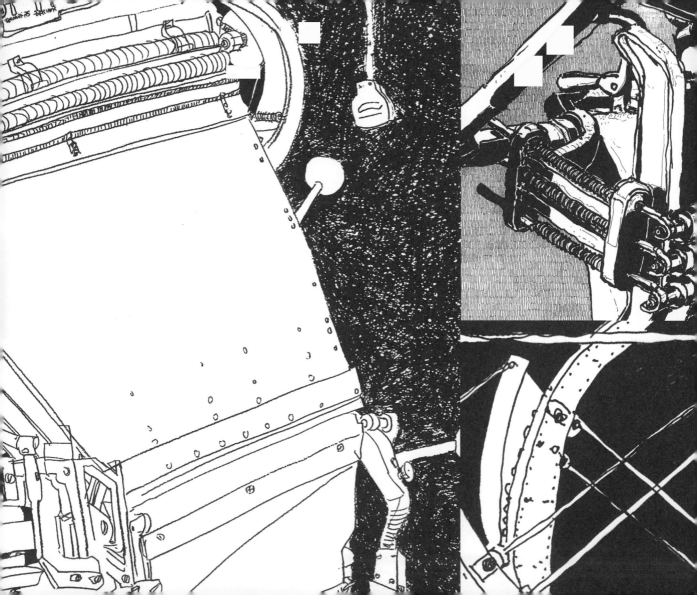

■ **DON'T BE AFRAID OF MACHINES!** These aren't technical drawings. They are created free-hand and can work out fine if you follow some tips: don't use a ruler and a pencil, use a pen instead so you can't rub it out. Try to leave each line alone, without wanting to correct it. Don't fret if the lines look crooked. Don't think about wanting to draw a complete machine.

Draw the parts in the foreground first. Pay attention to how flat the ovals are. Never draw their narrow sides pointed, always make them round. Should you have difficulties with perspective, keep drawing anyway. If the parts still don't match over time, just make them fit. If you get the impression that the machine could never work looking like this, it doesn't matter. It's your drawing that has to work.

This sort of drawing becomes more attractive when you manage to combine lines and surfaces with each other, blacken negative space and have varied hues.

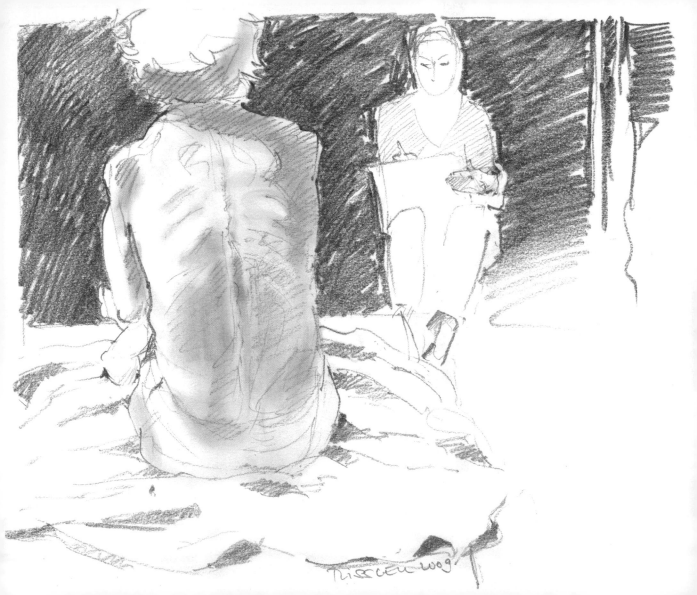

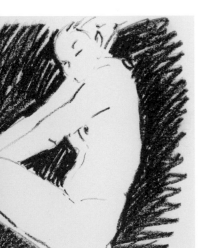

■ **IN THE LIMELIGHT** In nude drawing groups there is an almost prayer-like silence and a concentrated working atmosphere. Every noise has a negative effect on the drawings. As in portraiture, the result expectations are very high. Much wants to be mastered at the same time. Of course, the models want to be able to recognise themselves in the drawing. The proportions should be correct and any shortcomings should be seen correctly. Getting the ribs and spine right can send you to despair. You don't always want to hide your hands and feet either. And on top of this there's the expectation that you'll manage to do it in an expressive and spontaneous style of your own. And all in just a few minutes! Here's my advice: join a life drawing group. No other kind of drawing practice is as instructive as this!

Here's a suggestion on how to put a nude drawing in the spotlight. After a few "guide" lines that follow the contours of the body, you can draw a negative surface as a background. How much your draw inside these lines is then up to you. As you can see, not much is needed.

See also tips 95 and 96.

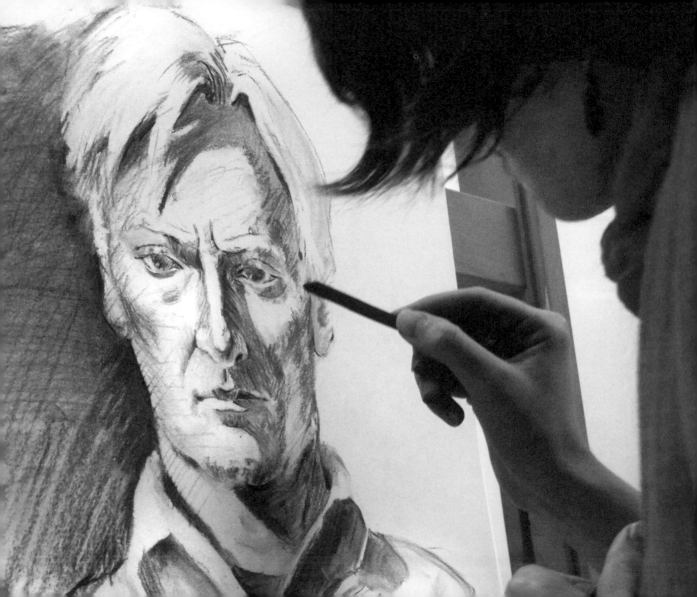

■ **LIKENESS** Tiny details decide whether or not a portrait resembles the model. This is true whether it is drawn in the style of one of the old masters, with just a few strokes or as a caricature. To prevent faces from getting stereotypical noses, lips or eyes, I recommend that you draw lots of different faces. There are some striking differences – including eyewear and hairstyles.

You'll get tips about the dimensions of the human head in a drawing class. I advise against courses that offer photos as examples to draw from. A good textbook can shorten the "learning stage", but it can't replace studying a model sitting in front of you. As well as life drawing, the only things that will help you are continuous training and the will to keep going when it gets difficult.

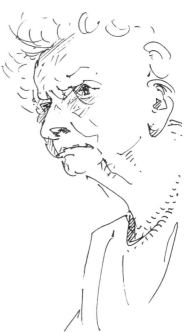

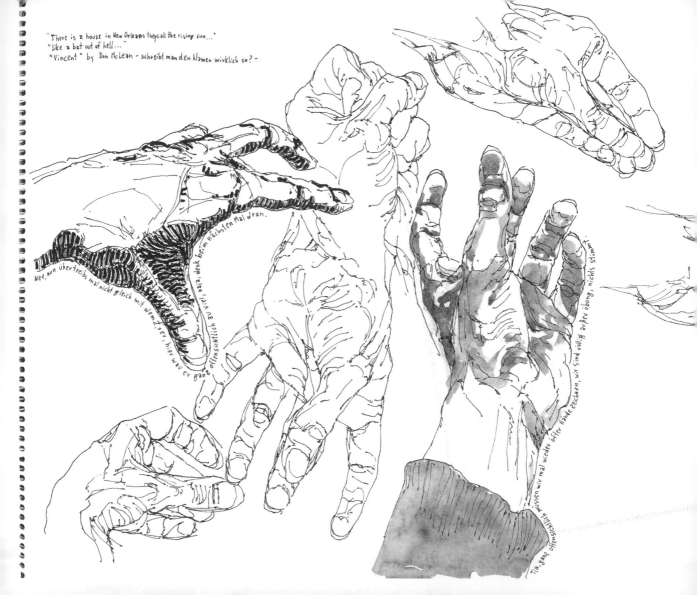

"There is a house in New Orleans they call the rising sun..."
"Like a bat out of hell..."
"Vincent" by Don McLean - schreibt man den Namen wirklich so? -

Nee, nun übertreibs mal nicht gleich mit dem Zoen, hier war er ganz offensichtlich zu viel, naja, denk beim nächsten Mal dran.

Tja ganz offensichtlich müssen wir mal wieder öfter Hände zeichnen, wir sind völlig außer Übung, nichts stimmt.

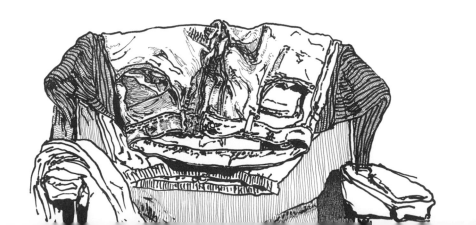

■ **STATE THE OBVIOUS** I suspect that a lot of people who draw are like this: you can pretty much manage to draw a person, but the hands and feet are an absolute disaster! How great it feels on those occasions when the whole drawing seems perfect, as if it popped out of a mould.

Rainer Lieser, who did the drawings on these pages, doesn't seem to have any trouble with this. With a good eye for proportions and effortlessly-drawn lines, he captures the most difficult objects using a technical drawing pen. A natural talent? Yes, but his skills are based on an enormous amount of diligence. Thousands of drawings fill large sketchbooks, which he used to document his private life, his time as a student and the city of Mainz. His drawings are like a rallying cry: stay authentic! Draw what is close to hand. Take a look around you!

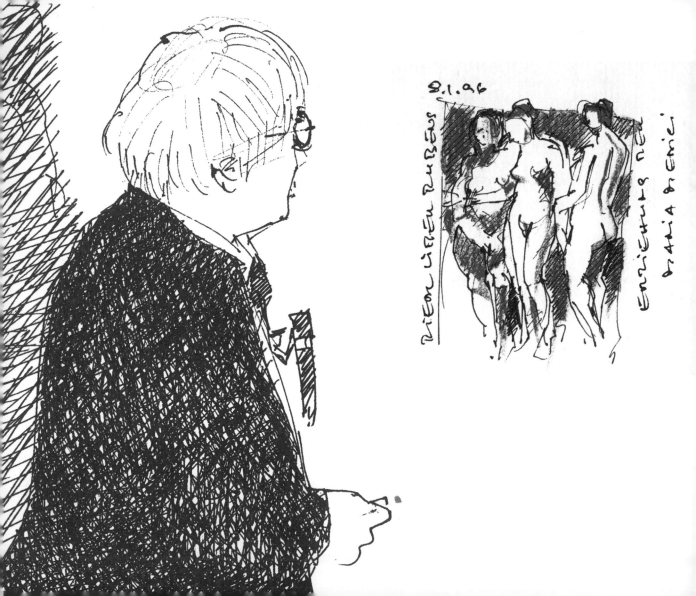

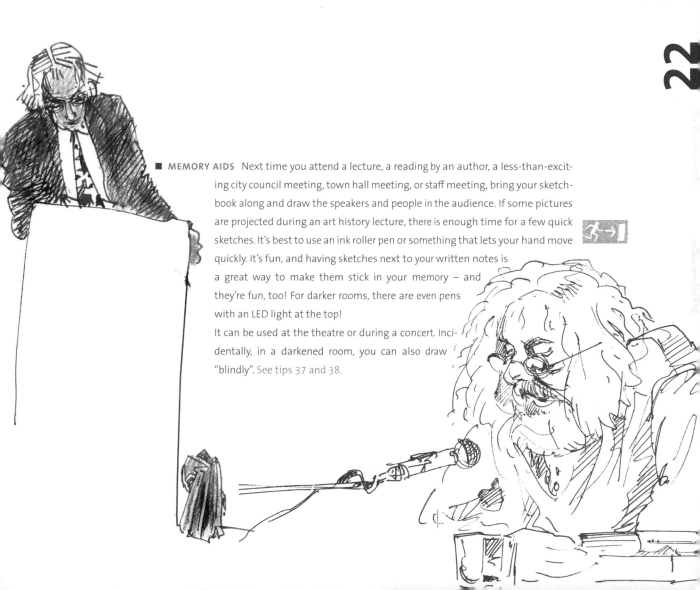

■ **MEMORY AIDS** Next time you attend a lecture, a reading by an author, a less-than-exciting city council meeting, town hall meeting, or staff meeting, bring your sketchbook along and draw the speakers and people in the audience. If some pictures are projected during an art history lecture, there is enough time for a few quick sketches. It's best to use an ink roller pen or something that lets your hand move quickly. It's fun, and having sketches next to your written notes is a great way to make them stick in your memory — and they're fun, too! For darker rooms, there are even pens with an LED light at the top!

It can be used at the theatre or during a concert. Incidentally, in a darkened room, you can also draw "blindly". See tips 37 and 38.

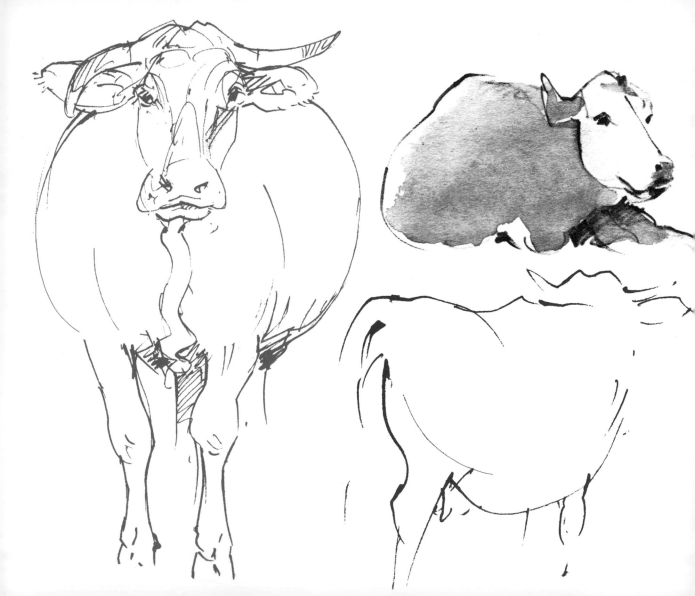

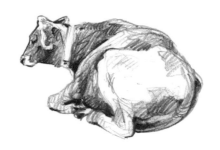

■ **CATTLE** have appealed to painters, drawers and sculptors for millennia. Think of the prehistoric paintings in the cave of Altamira, the depictions of cattle by Dutchman Paul Potter, the German impressionist Heinrich von Zügel or the bullfighting etchings by Pablo Picasso.

A cow's stocky shape is most beautiful when it is lying down to chew the cud. With your eyes half closed, you can make out their large shape. Observe the switch between concave and convex contours. Avoid bundling lines. It takes a few sketches to get used to their body shape. In order to understand their form from the inside out, it helps to have a good textbook so you can study the structure of their skeleton and muscles. But nothing beats sitting near them on the grass. With each new sketch, your knowledge of their anatomy will improve. In-depth study is par for the course.

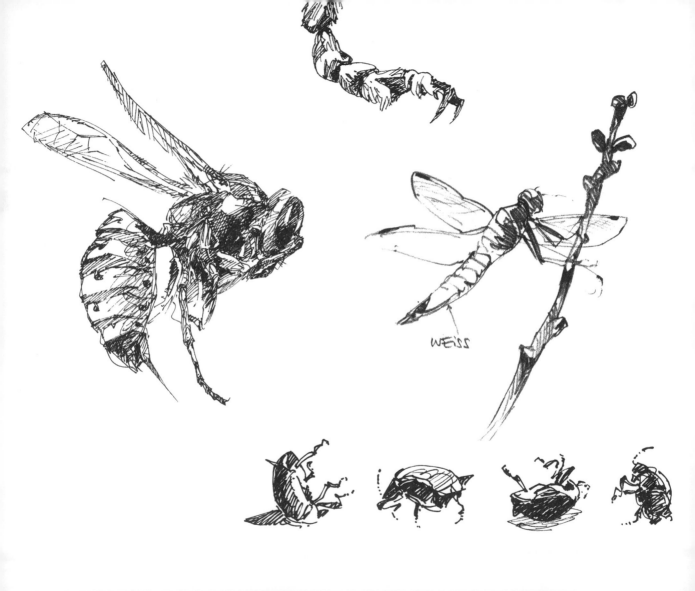

WEISS

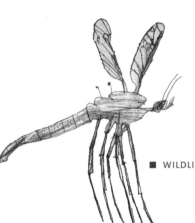

■ **WILDLIFE UP CLOSE** Draw the harmless mason bees as they buzz around a hole in the wall of a house in the spring. It's fascinating what happens throughout the year. You could briefly rob a black woodland dung beetle of its freedom and sketch it. Dead flies found around the house are also suitable for a few case studies. There's a zoo all around you! And it's free entry. Use a magnifying glass to discover the details on insects' legs that you wouldn't usually see with the naked eye. They are always constructed in the same way, but their shapes vary tremendously. They are biomechanical marvels and delightful to draw. Sketch the details — ultralarge. Use a pencil first. If you are more familiar with the details, an ink roller pen or fountain pen is the right instrument. With some practice, you can sketch insects from memory. Draw with children. That way, they learn what a tarsus is, that a hoverfly is not a wasp and that the useful spider is not an insect. See also tip 87.

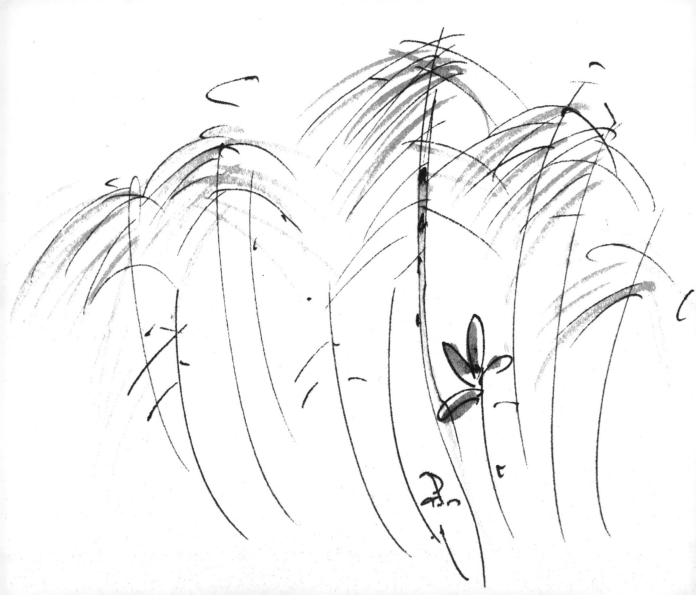

■ **LESS IS MORE** What's the story behind this oft-used feedback about drawing? The answer isn't easy to explain, because our fascination with drawing is pretty much fed from two sources.

For those who are able to depict reality with detailed precision in their drawings, admiration is always certain. Is it merely a craft then? If that were so, one would have to consider the works of many famous artists as being something that could simply be learnt. It makes me think of Albrecht Dürer's "Praying Hands".

We admire those who are capable of portraying something easily using just a few lines, apparently without effort, at the drop of a hat. Apparent ease, courage, confidence and decades of drawing practice lead to what many would describe as "skilful". If you have a good visual memory, then you're in luck. When these skills come together, what is commonly called "innate talent" comes into being – an ideal prerequisite for giving maximum expression to subject matter with minimal effort. What fascinates you about drawings, which ones leave you feeling indifferent? Sharpen your judgment by looking at as many drawings as possible. This has a direct impact on your work and every single drawing you do.

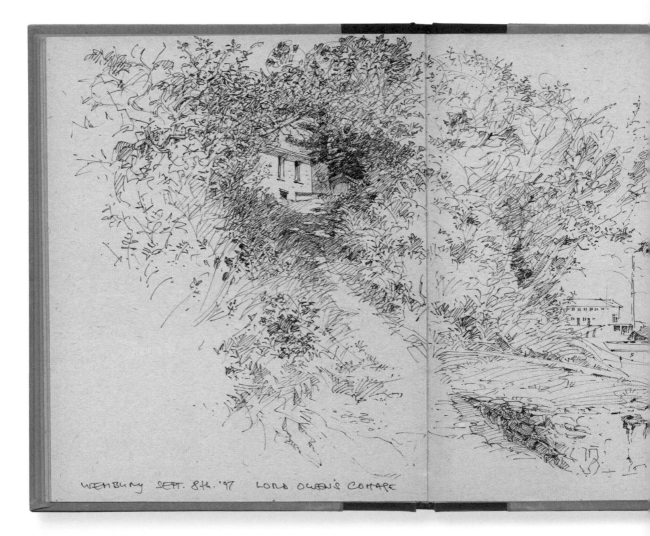

WEMBURY SEPT. 8th. '97 LORD OWEN'S COTTAGE

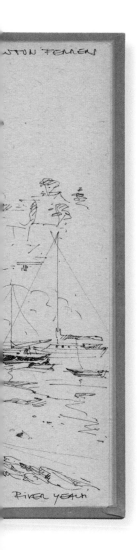

RIVER YEALM

■ **SPARSITY AND DENSITY** These are drawings I did in the South of England. I used a very fine ink roller pen on high wood content paper, which a bookbinder made into a sketchbook for me.

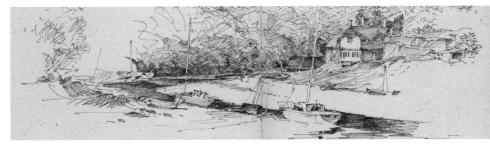

With these sketches, I'd like to draw your attention to the tonal values that are created solely with lines. With parallel hatching, surfaces can be darkened very quickly. More concentration is required for structures that indicate foliage, for example, like shorthand. When bright sections of the picture are surrounded by very dense lines or structures, the effect it has is very interesting. Sometimes they even appear to be lighter than the blank paper. Try it out!

26

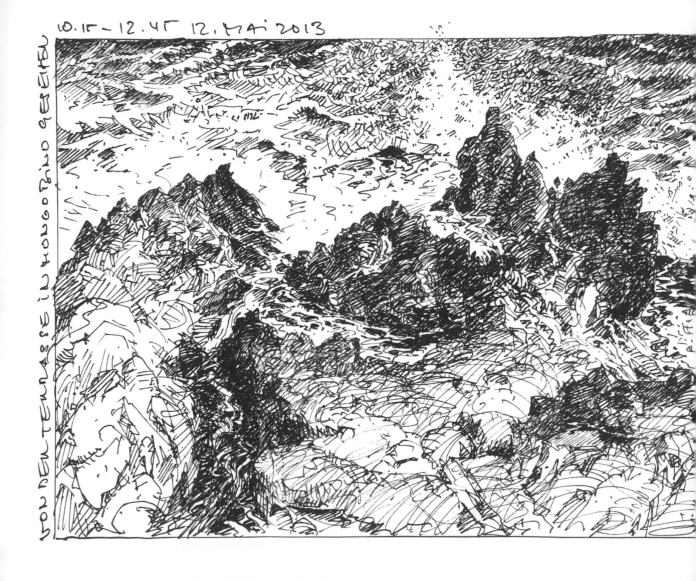

DONNERT, KRACHT UND ZISCHT. DAS MEER SPIELT SEIT STUNDEN.

■ ON THE SPOT Why torture yourself? Take a quick picture. The choppy sea stays still then. This makes it easier to draw. Or maybe I can challenge you to face this crazy drawing subject matter? The most important reason you should try it is that the experience of every stroke, every detail of the drawing, connects with everything that happens around you. If you spend a few hours paying attention to the movement of the waves, in years to come you will hear the rushing water and the cries of the seagulls, smell the salty air, or even know how warm it was. If, once you're back home, you make a two-dimensional drawing of a photo that took seconds to snap, you won't have that overall impression of the scene. In situ, you'll make some great pictures — even if they're not perfect. If you draw from photos, you will focus on copying the aesthetics of the photo. A technical process that can only replicate. Nothing more.

See also tip 42.

See also tip 42.

27

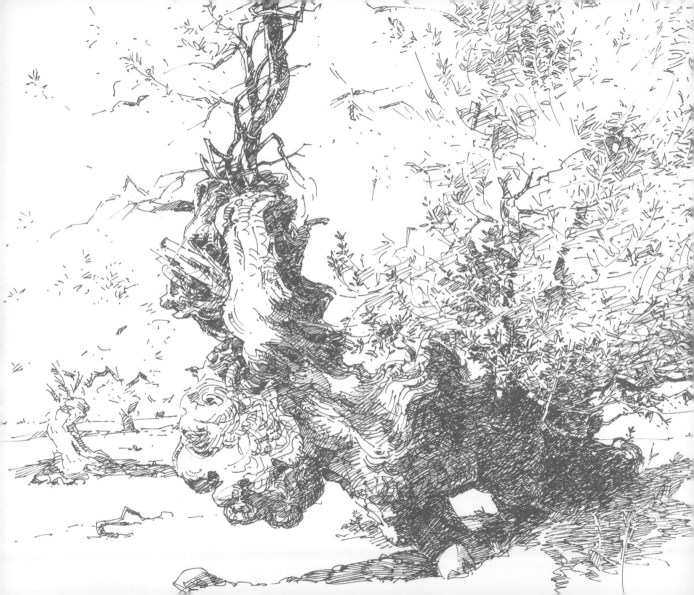

■ **DRAWING SIGNS** Handwriting is the "liquefaction" of abstract typefaces – without a doubt, it's a way of drawing. You could also think of drawing as a way to write signs. Symbols that have to be found to describe the structure of a leaf or the bark of a tree for example; they are nothing more than summarily assembled, individual pictorial signs which, depending on the level of abstraction, are more or less easily decipherable.

You can recognise the handwriting of a skilled artist by its fluid form. Creating and writing characters that have no purpose, quickly stringing words together or interweaving them encourages the development of a persuasive and individual character style. Brush pens, crayons, ink roller pens or ballpoint pens – any kind of writing instrument is suitable. See also tips 29, 74 and 105.

28

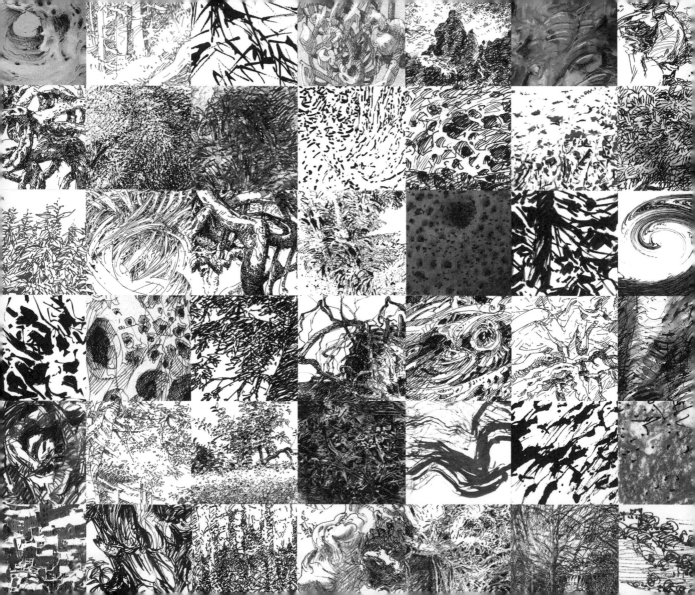

■ **COPYING NATURE?** Artists are collectors. They are attentive observers and draw long before they pick up a pen. They love beautifully structured things that challenge them to think about how they would draw them. What design vocabulary would be required for the leaf canopy of a sycamore tree; what sort of shorthand symbol could depict a meadow; how would you characterise limestone rock; how do you portray moving water graphically, so that anyone looking at the drawing is able to decipher it? This is not easy, given the dizzying variety of things that the visible world offers to artists.

The most important task is to try to give things their own character. Any amount of effort to make a copy of nature is doomed to failure. Even the most precise imitation is already the beginning of an abstraction of reality. The challenge is to draw structures with minimal means so that they can nevertheless be "read".

Take a look around you. Start off with everyday objects. Or bring something home with you after a walk and get started. See also tips 28, 74 and 105.

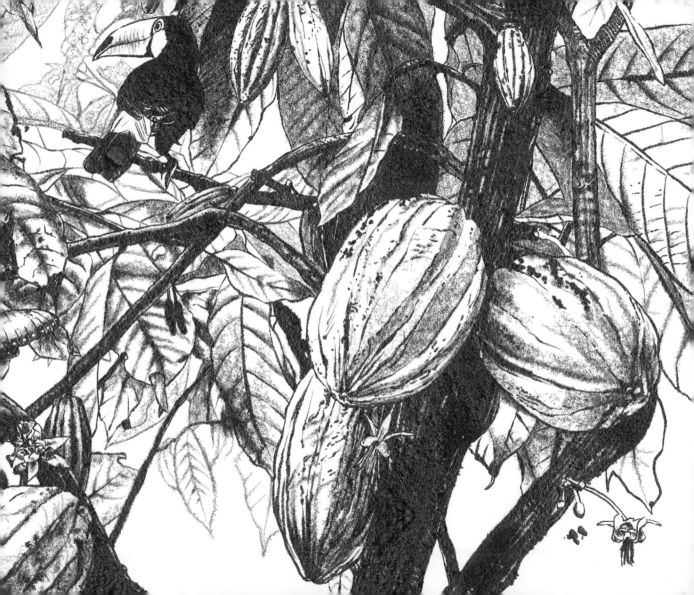

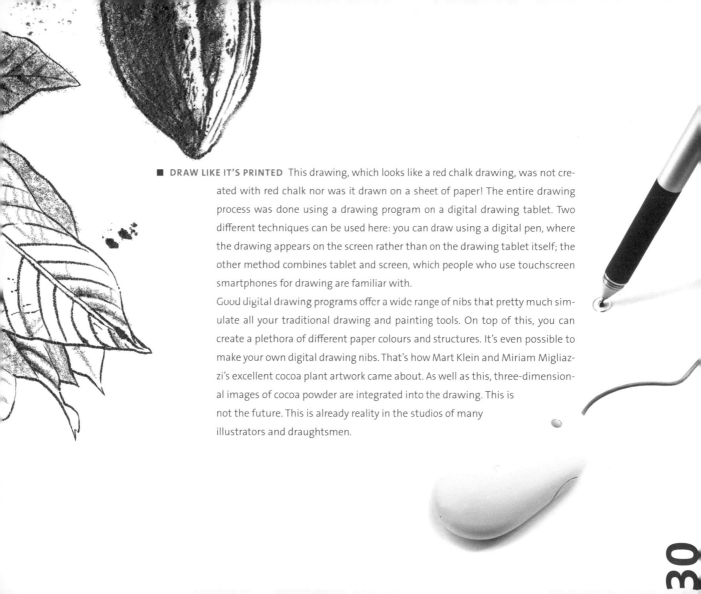

■ **DRAW LIKE IT'S PRINTED** This drawing, which looks like a red chalk drawing, was not created with red chalk nor was it drawn on a sheet of paper! The entire drawing process was done using a drawing program on a digital drawing tablet. Two different techniques can be used here: you can draw using a digital pen, where the drawing appears on the screen rather than on the drawing tablet itself; the other method combines tablet and screen, which people who use touchscreen smartphones for drawing are familiar with.

Good digital drawing programs offer a wide range of nibs that pretty much simulate all your traditional drawing and painting tools. On top of this, you can create a plethora of different paper colours and structures. It's even possible to make your own digital drawing nibs. That's how Mart Klein and Miriam Migliazzi's excellent cocoa plant artwork came about. As well as this, three-dimensional images of cocoa powder are integrated into the drawing. This is not the future. This is already reality in the studios of many illustrators and draughtsmen.

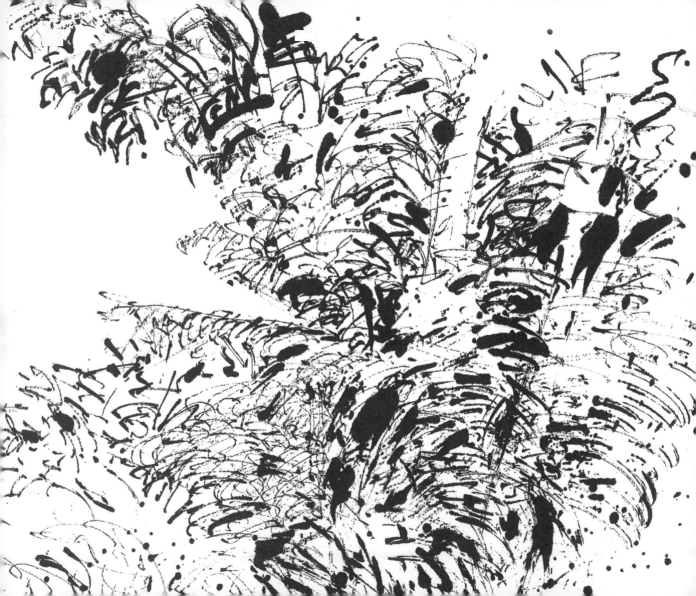

■ **ANYTHING THAT DRAWS** is a drawing instrument. There's nothing you can't try out. So, how about using those pipette things that are attached to the lid of a paint pot? Here's an ink pad with fresh ink being brushed with a paint brush, and a pointed tube that can draw liquid out of an ink bottle. The third one is a normal pipette, which illustrators use now and then. Each of these strange drawing devices creates a different kind of line. What they have in common is that it is difficult to control the amount of paint that comes out and that the lines run together somewhat. But that is exactly what makes this technique so appealing and you can it try out with lots of different subject matters. With a little practice, you can quickly find out how to make fine lines or when splotches are in order.

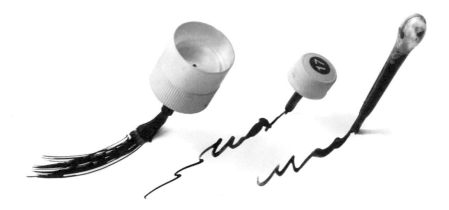

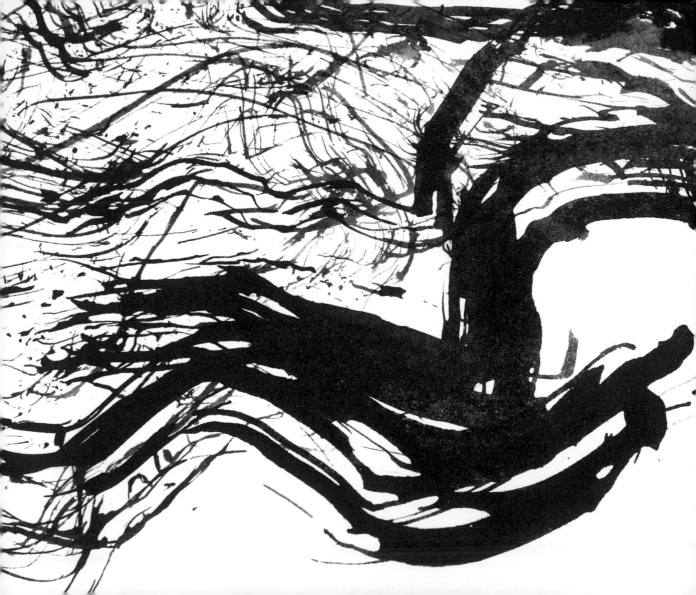

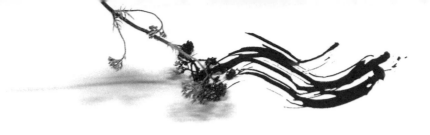

■ **INSPIRATIONAL BISTRE** A piece of old wood, a bit of greenery and a glass of bistre. That's all you need for this drawing experiment. The structure of the wood inspires you to try it out. The plant, as a barely controllable drawing instrument, prevents you from getting too bogged down with the details. The ink offers a rich spectrum of beautiful brown tones. See also tip 15.

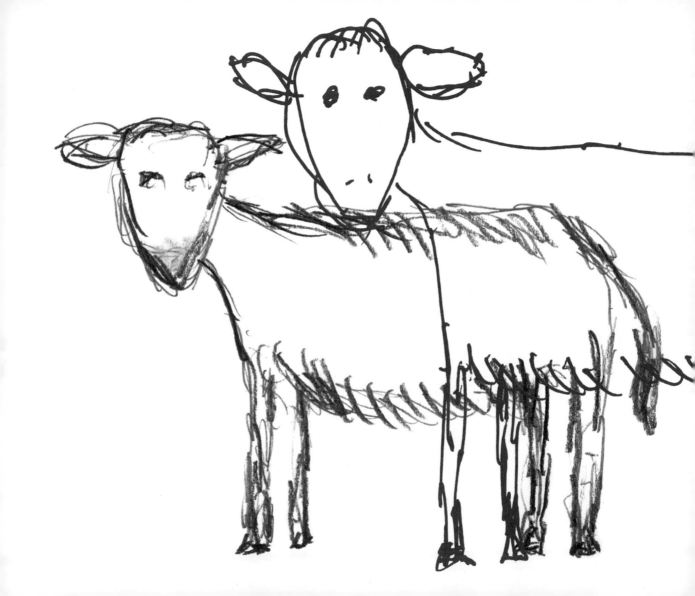

■ DRAW ME A SHEEP Saint-Exupéry calls out as he wakes up in the desert. But "the little prince" was not satisfied with any of the attempts made by the aviator who had made an emergency landing there. Here, Saint-Exupéry describes the frustration of many adults who want to draw. How difficult they make it for themselves by drawing outlines again and again until the "ideal" line disappears within them.

These "woolly threads" are seldom seen in children's drawings. They are drawn with clean lines. With the onset of puberty and with adults who are starting again (a 63-year-old did the picture here on the left), the demands on oneself to be perfect hampers original spontaneity. Noticing the gap between what you can see and what you're able to do can permanently ruin the fun of drawing. If you do draw "woolly threads", try to leave the lines as they are, don't correct them. Then you see that a drawing isn't just good because it is "correct". Benjamin (5) and Linus (8) show us that sheep can also have their accuracy.

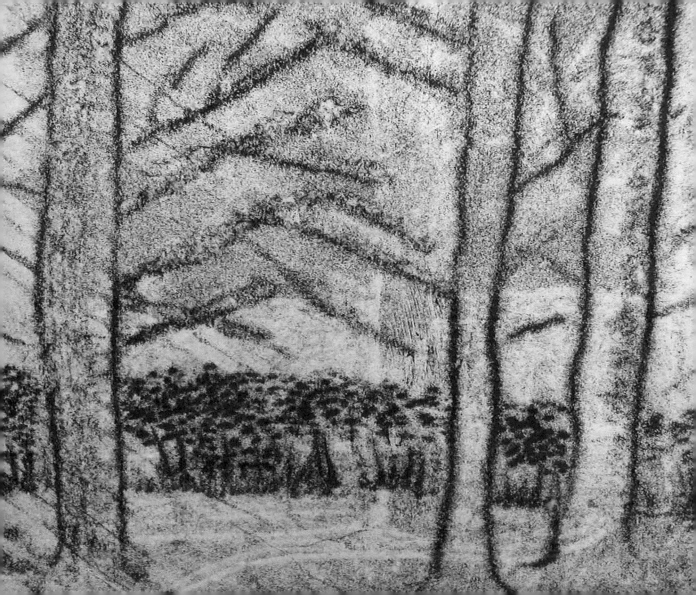

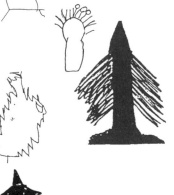

■ **IT'S NEVER TOO LATE!** It is astonishing how early on children are able to illustrate their impressions in a concise manner. Moreover, if their drawings are original and well-observed, rather than just being influenced by the flood of images rushing at them, this is an indication of their creativity. If creativity is to be nurtured, parents can do a lot of good in their selection of images and playing materials. With the onset of puberty, when youngsters become critical of themselves and their surroundings, and start looking to role models for guidance, artistic independence is sometimes lost. Here, art education has an important role to play. Whether or not the support received by teenagers was appropriate to their needs, is reflected in the artwork of adults – they remember their own pleasure in drawing and painting as children and therefore attend classes again. Since their idea of what constitutes a "good" drawing has increased, there is often a gap between what they want to do and what they are able to do. To their complete surprise, their artwork looks like it was done by a child. As the picture on the left shows, this needn't be cause for concern. My advice: don't give up! Through intensive visual training and constant practice, a lot of skills can be recovered and new ones learnt. By the way: The tree drawings are by children aged three to seven years.

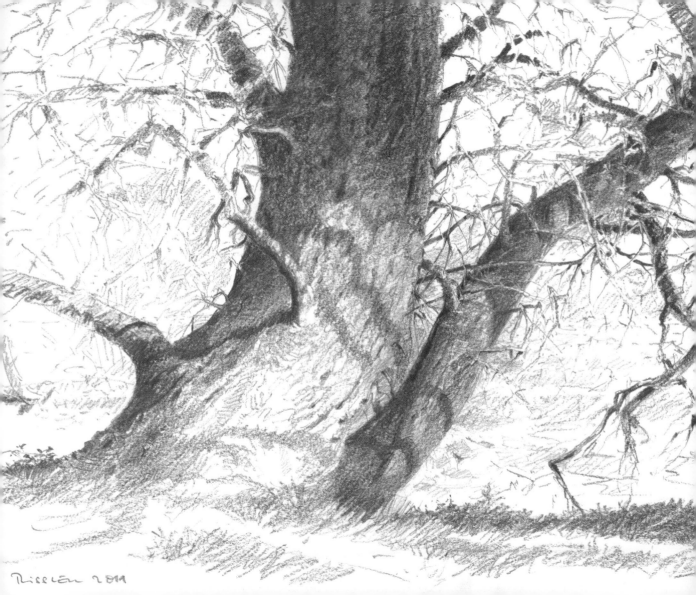

Rieeleu 2011

■ **FIRST TRY IT WITHOUT** Three-dimensionality is difficult to achieve using hard lines. Out-lined objects can look like they've been cut out and glued on. Those who are used to drawing this way, but can resist drawing borders for a while, might be surprised at how easy it is to create a three-dimensional appearance. The best way to do this is with a soft pencil. Of course, you tend to use lines to design and look for the shape of an object. But when you draw these lines lightly, they dis-appear among the tonal values that are added later. Practice looking at the brightness scales – or values – of simple objects. Take a small, round stone – or even better, an angular one. Then you can apply three-dimensional drawing techniques to more complex objects and later try out tonal gradations with hatching. See also tips 36 and 40.

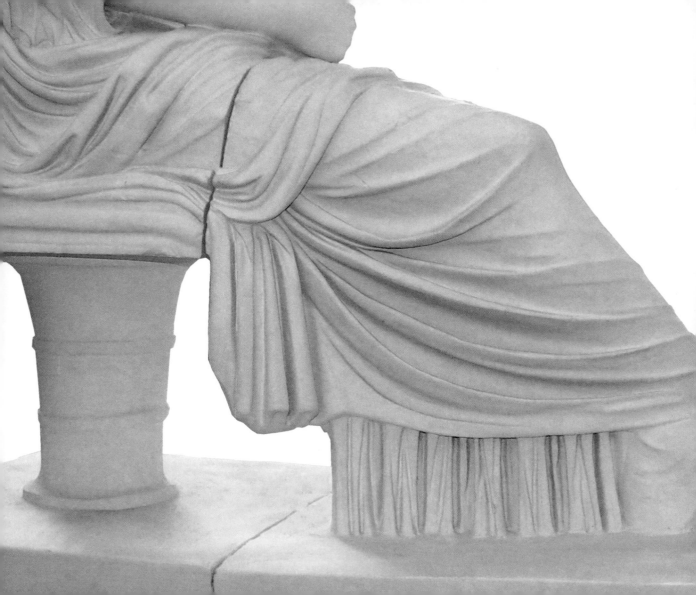

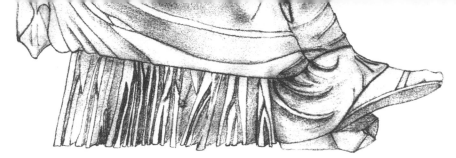

■ **KEY EXERCISE** The pencil drawing above was done by an art student. The class task was to draw the robes of a Roman lady. They worked in front of a cast of an antique marble sculpture, and from a photo of it.

Do you see how flat the drawing appears? This is because of the lines around the folds. It doesn't take much to see that the object doesn't have these lines. Although there are clear shapes created by the difference in tone, there are no linear borders! Other than that, the garment consists of fine tonal gradients and shadows, which shape the wrinkles. The pencil study below, from a section of the panel painting "St. Laurentius" by Matthias Grünewald, shows how tangible a garment can be made to look without a linear border.

Drawing wrinkles is a key exercise. It opens doors to all sorts of challenges that drawing has to offer. See also tips 35 and 40.

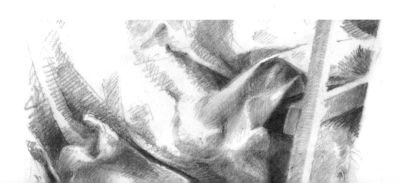

■ BLIND DRAWING doesn't mean drawing with your eyes closed. They stay open. They just don't control what happens on the paper. What the artist sees flows directly through the hand that is drawing. The usual corrections are gone. I have tried this way of drawing time and again, by myself and with my students. Always with the same result: the drawings are considerably different to their usual style. The lines are spontaneous and confident. On the whole, the results are surprisingly original.

Blind drawing is not an end in itself. What becomes clear is that right can also be wrong, or in other words: the quality of a drawing is essentially shaped by the expressive power of the lines and not just by whether or not the subject matter has been drawn "correctly". So it's always worthwhile to refresh the usual drawing technique with some blind drawing See also tip 38.

37

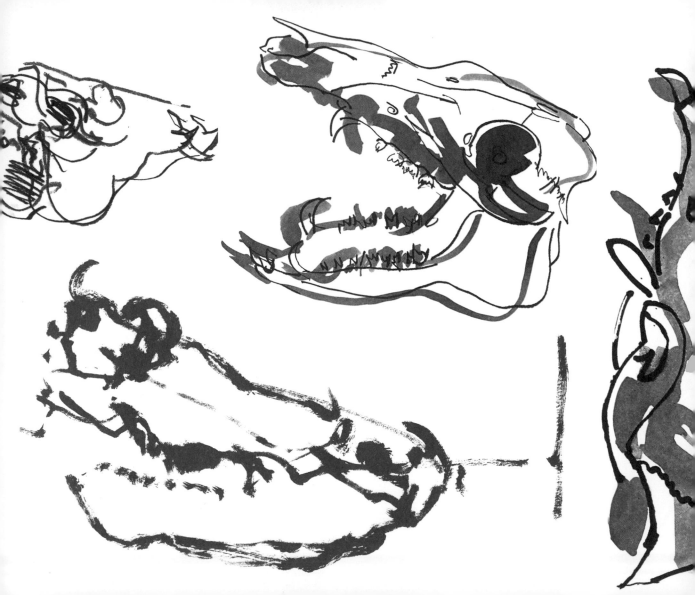

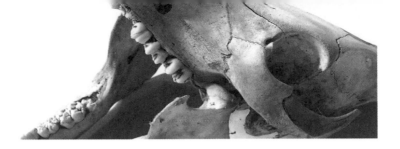

■ **WILDLIFE SKULLS** Of course, blind drawing can achieve expressive results with any subject matter. The drawings shown here are from a group of artists who sat in a circle around the skull of a wild boar. The rules of the game: everyone has to look at the object. Nobody is allowed to check what is happening on their piece of paper. Blind drawing encourages self-confidence, spontaneity and expressive drawing, which is reflected in every single line. Here it becomes particularly clear that whether or not a drawing is "good" doesn't depend on whether or not it is a "correct" depiction of the subject matter. Important tip: be careful not to draw stereotypical formulas when drawing blind. Rather, try to study the specifics of the object, even if you can't improve them on paper. See also tip 37.

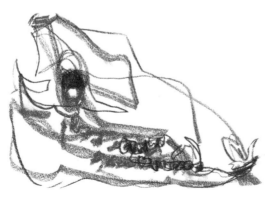

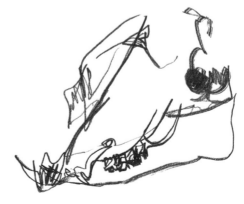

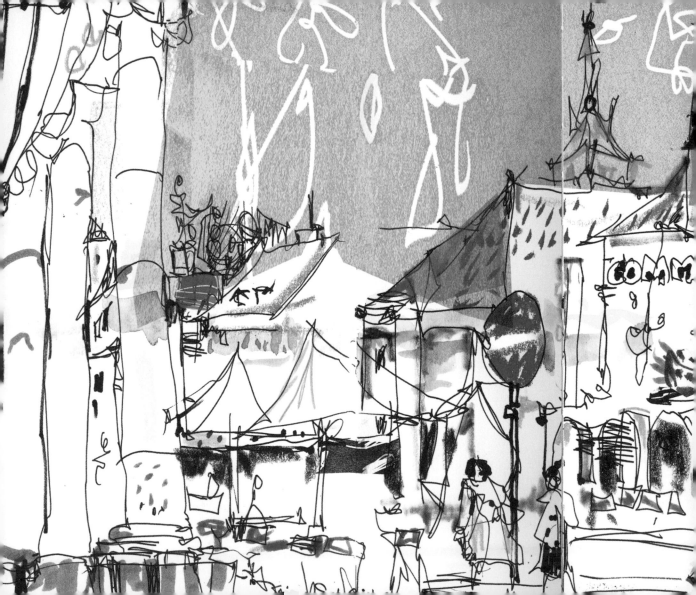

■ **RESPONSIVE** With cameras, a bustling city can be frozen in a single click. Drawing it isn't quite as easy. A drawing, depending on the subject matter, style and technique used, takes a while to do. Scenes that constantly change have to be captured quickly and collaged together. For this, you need experience and a repertoire to fall back on.

Karin Schliehe drew this scene with a black pen, while sitting directly in front of it. You can just imagine how the pen flew over the sketchbook. Buildings are only hinted at, and yet Stuttgart natives will immediately be able to make out which square it is. You can really see where the artist was sitting and in which direction she was looking. Back in the studio, colours were added to the drawing, before scanning and digitally processing it with Photoshop.

If you are used to drawing with great accuracy or from photos, I advise you to try drawing a scene like this outdoors. Even better, use drawing tools that can't be rubbed out. Let them run wild! "Accuracy" doesn't have to be the primary goal here. Quite often, it is the lines that are drawn impulsively that make drawings attractive.

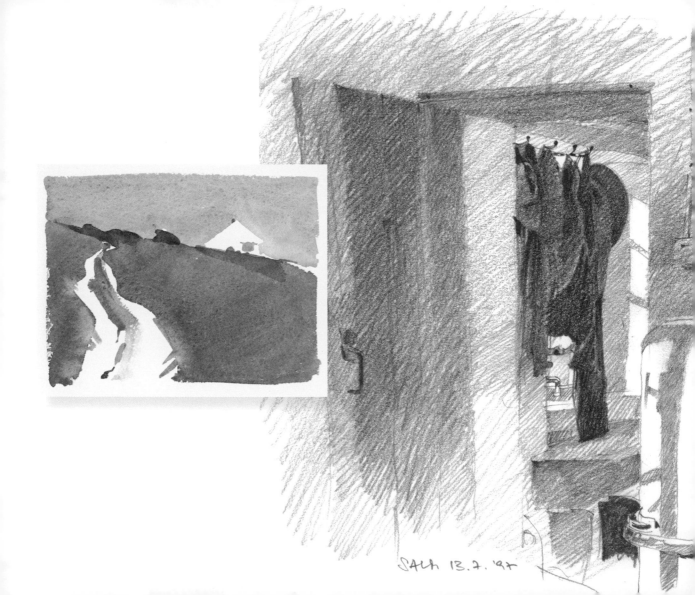

SALI 13.7.'97

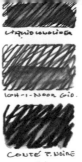

LIQUID COALIIER

KOH-I-NOOR GIO.

COUTÉ T. NOIRE

■ **WHAT HAVE WATERCOLOURS GOT TO DO WITH DRAWING?** Quite a lot actually! If you want to paint using the far from simple watercolour technique, you have to decide quickly which areas of the paper should be painted and which bits should be left blank.

The prerequisite for this is the ability to recognise the juxtaposition of positive and negative surfaces in the subject matter, in order to be able to depict light, for example. With watercolours, lighter parts of the subject matter can be brought out using the "grey value" of the coloured areas. The same thing happens when you draw tonal values with graphite, ink roller pens, chalk or charcoal.

When painting with watercolours, drawing with tonal values is therefore an essential preparatory exercise for field of vision. Unfortunately, it is quite common that people who want to learn to paint start off with watercolours. Ironically, this is the most difficult of all painting techniques! So this leads to frustration. Or flying off into a supposedly "abstract" painting style that just about covers up the difficulties. A more suitable intermediate step is a technique that combines lines and tonal values. Water-soluble pencils, paint or graphite crayons are good for this. See also tips 35 and 68.

ALBRECHT DÜREN

QUICKTIP DOFER

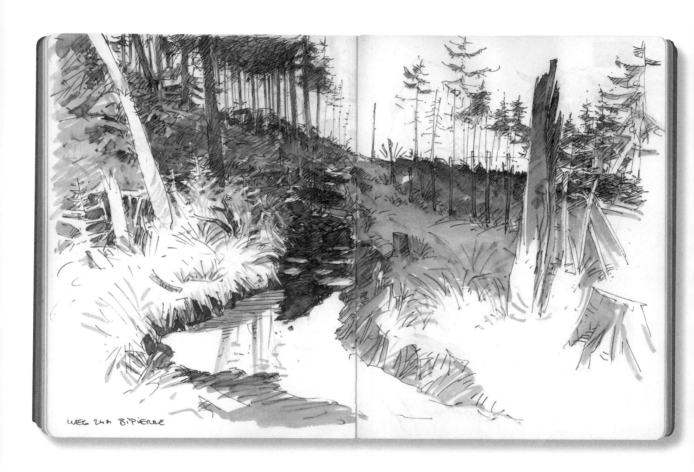

WEG ZUM BIPIERRE

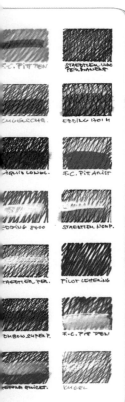

■ **COLOUR WASHING** that isn't wishy-washy. For example, use a non-waterproof felt-tip pen – you can dissolve its lines with a damp brush. In this way, hatching can be made denser and you can create tonal values or lighter patches between the gaps. Not every pen is right for this though. Some pens are quite dry; others have ink that just flows out. It's best to try out everything you can find in the pen drawer. A sketchbook is good for testing them out. If the paper is slightly absorbent – even better. If you write down the names of the pens next to the ones you've tested in the sketchbook, you can always look them up later on to see how their inks react when you use water to paint with them. Countless mixed-media possibilities come about when you use paint instead of pure water: watercolours and semi-opaque tempera or acrylic paints lend themselves well to this sort of combination. You can try out opaque white on coloured paper. A trimmed bristle brush creates a more striking effect than a soft watercolour brush. See also tips 51 and 77.

41

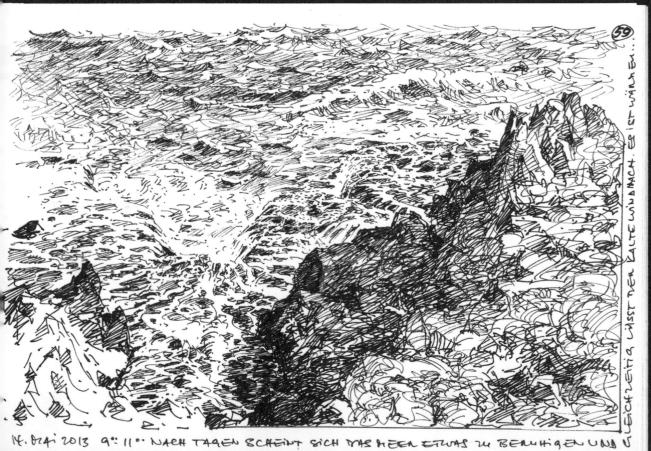

59

14. DEZ 2013 9°: 11°° NACH TAGEN SCHEINT SICH DAS MEER ETWAS ZU BERUHIGEN UND GLEICHZEITIG LÄSST DER KALTE WIND NACH. ER IST WÄRMER...

■ **RIGHT NOW!** On his deathbed at the age of 89, Japanese painter, drawer and woodcarver Hokusai – who had been admired during his lifetime – is supposed to have said: "If heaven would just afford me another five years, I could become a great artist." Hidden behind this statement are some insights that all serious artists are aware of. You're never satisfied!

Even when you're happy that a piece of work has turned out well, the idea that it could have been even better is sometimes the engine that pushes you forward. Satisfaction would equate to a stalemate. Drawing is a never-ending process of seeing, learning and training. This means that artists should not avoid difficult subject matter. Quite the contrary! With a wink to the musician Miles Davis you could say: don't play what you can; play what you can't. See also tip 27.

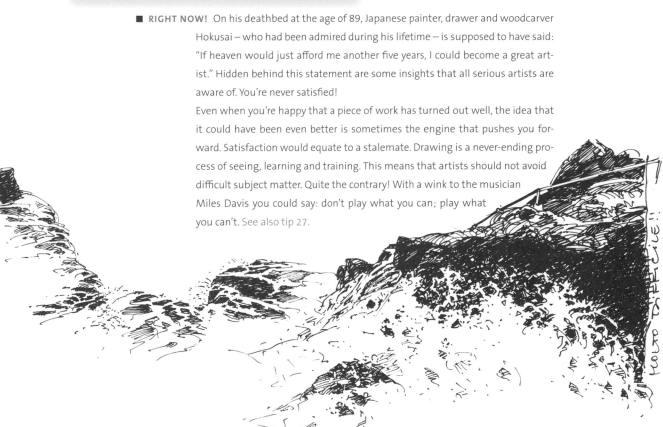

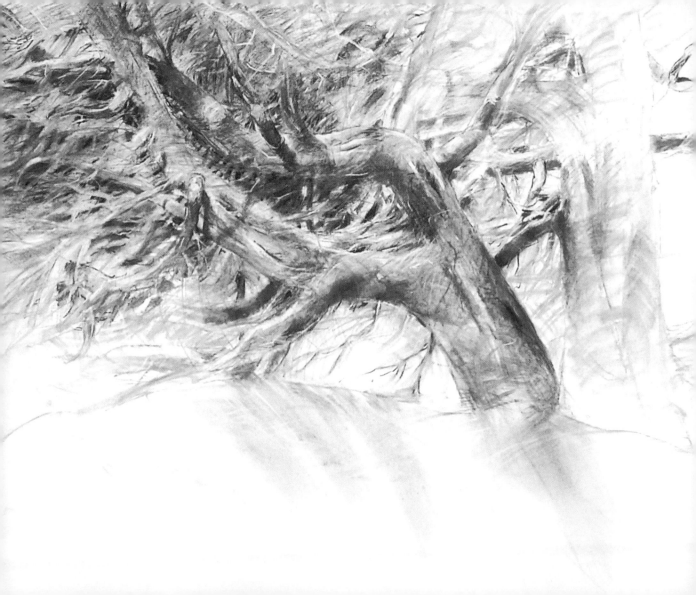

■ **INSPIRATION FROM THE SKETCHBOOK** Maybe you have a drawing in a sketchbook that you'd like to see in a large format. You can get craft paper on a roll, which can be cut to size and fixed onto a solid base. The finished work needs a stable frame with protective glass. It's quite expensive and complicated!

Here's a much simpler solution: with charcoal, draw onto a primed, relatively smooth canvas. Ready-stretched canvases are pretty cheap. 100 × 100 cm is a good size. This size is still easy to handle on a simple easel.

Don't look at your drawing in the sketchbook as a master copy that needs to be translated across exactly. Indulge in the particularities of drawing with natural charcoal. Use your fingers and estompes to smudge it, or you could also use a kneaded eraser, which you can also use as a drawing instrument to make dark areas lighter again. When you've finished, you should protect the drawing with a fixative spray used sparingly.

■ **COULD IT BE A BIT BIGGER?** Brush drawings on large canvases that are usually *painted* on are not what you would normally expect from an image carrier. Here is an attempt to depict a sunken lane, using the simplest forms. Loose and compact structures, as well as movement in multiple directions, are the means of expression in this drawing.

Brush drawings on canvas are particularly attractive if you want to go beyond the usual drawing paper format size. Simple, primed canvases in standard sizes are relatively inexpensive. Special formats, or oversized canvases, must be made to order.

Acrylic paints are the easiest to use. You will quickly find out what the right consistency is: straight from the tube, mixed with water or combined with a painting medium.

■ **FROM THE SHOULDER** This advice is for artists who are used to drawing hesitantly, with a hard pencil, on small formats, their nose close to the paper. Using an easel from time to time could help you stop procrastinating. It stops you resting your palm, which can inhibit your stroke. Motor skills are not limited to the fingers and the wrist.

When drawn from the shoulder joint, drawings become more fluid and spontaneous. Thick pens and good functioning drawing tools will help. Easels have the advantage that they can be adjusted so that the view of the drawing paper is held approximately at a right angle. Above all, vertical orientations of the subject matter can be correctly estimated and reproduced. Anyone who has ever drawn a nude model or a portrait on a piece of paper lying flat in front of them is familiar with this problem. Another advantage is that you can take a few steps back to view the work from a distance, so you can contemplate the composition as a whole. On a side note: maybe try out an easel to make things easier – there are some affordable ones available on the market.

■ **ART OR ENVIRONMENTAL POLLUTION?** The answer to this can be very controversial. The fact remains: whoever did this two-metre-high graffiti must have amazing motor skills. These are drawings, even if they were created with a spray can. You too should strive to achieve the eye-catching power this graffiti has. Constantly training your hand is part of what drawing is all about.

There are exercises you can do that will give your drawings "some kick". Here's a suggestion of an exercise you can do with any sort of pen. At the bottom of a piece of paper, quickly draw a line that bulges and zigzags slightly. Draw another line in close parallel with the first one. With each line, the bulges start to get more pronounced. If you make the gap between the lines larger on the left, going narrower towards the right, you get a three-dimensional effect. It needs concentration, it's fun and it's great for training fine motor skills of the hand.

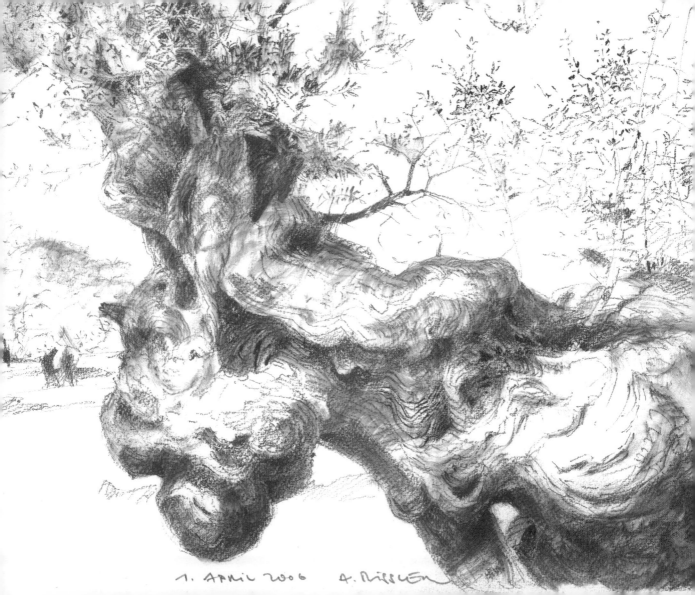

1. APRIL 2006 A. RISSLER

■ **FREEDOM** I can remember the first time I was in an olive grove. I ran from tree to tree as though intoxicated, in search of the one that looked the most interesting. No tree looked like the other. Neither in overall shape nor in the structure of the

bark. Depending on where I stood, each tree took on a completely different shape. It's hard not to imagine human limbs, animals or mythical creatures. When taking on the bizarre forms of olive trees, an artist has two possibilities. Either you challenge yourself to depict a particular tree's shape in minute detail, or you allow the "creativity" of the olive trees to infect you and play imaginatively with the shapes it offers up. There is no right or wrong way to do it. Using these enchanting trees as an example, you can find out just how much artistic freedom you can have when you draw, without losing sight of the original object. See also tips 100 and 111.

47

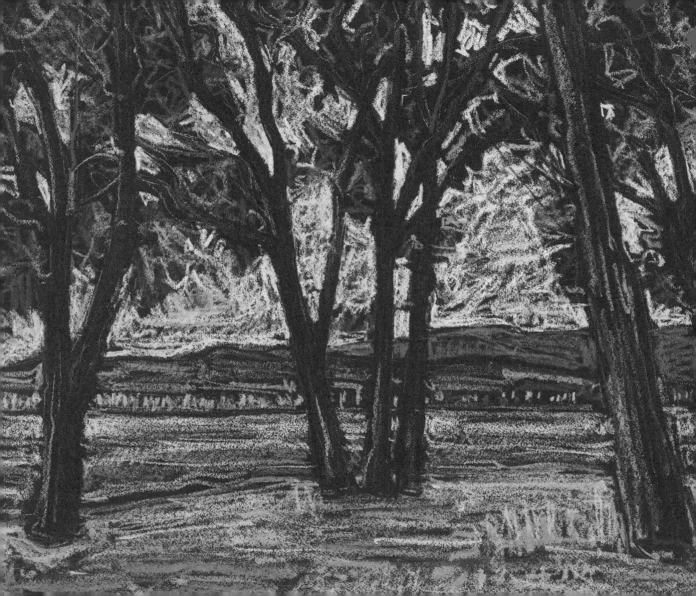

■ **THAT FIRST SPARK** There are lots of reasons why I want to show you this pastel drawing. Firstly, for the rhythmically structured row of trees in the foreground that creates a trellis effect against the view of Lake Constance and the ridge behind Bodman-Ludwigshafen in the background. It is a visual concept that was adopted by western artists following the Japanese woodblock prints of the mid-19th century, which lead to Japonism. For example? Search Claude Monet's 1891 painting, "Poplars on the Banks of the Epte".

The drawing technique used by Bernhard Buss (1899-1991) is particularly interesting. He would draw on jet-black cardboard with pastels. This requires some rethinking when you're used to drawing on white paper. You don't have to painstakingly leave all the light bits blank – you add them instead! It's just the thing for his fast drawing style.

Another reason is a somewhat personal one: as a 12-year-old, I had the honour of doing my first landscape drawing in the presence of Bernhard Buss. That first spark had a real impact. This sort of experience is essential.

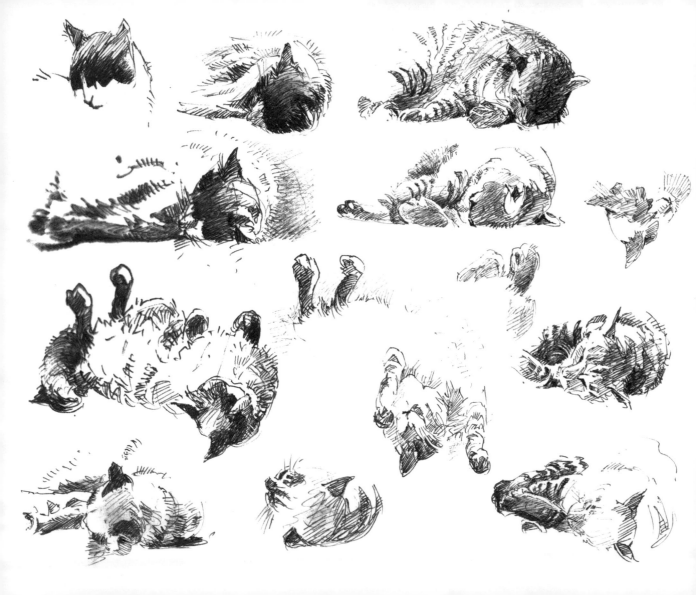

■ **THE WEAKLING** The pen isn't just a writing tool; it's also a decent drawing device. In contrast with an ink roller, which draws clean lines with liquid ink, the strokes of the ballpoint pen are much softer. This is because its ink is an oil-like paste, which can sometimes be greasy — but this needn't be a disadvantage. Quite the contrary in fact: you can rub this sort of line with your finger, or better still with a wiper paper, to create delicate tonal values. This effect is illustrated by the cat sketches pictured here. Although you usually need to press harder with this sort of pen when writing, you should use it with a light hand when drawing. It's good for small, finely-detailed drawings. Fluffy cat fur is therefore particularly suitable subject matter. Since the ballpoint pen is sold as a writing instrument, its paste-like ink is usually permanent. Of course, you can't always rely on this mass-produced item. Cheaper versions sometimes have uneven hues. A quick test can clarify this though.

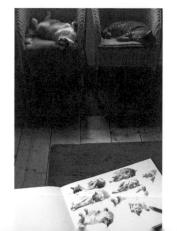

49

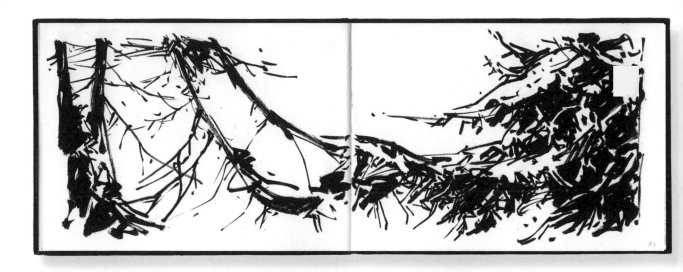

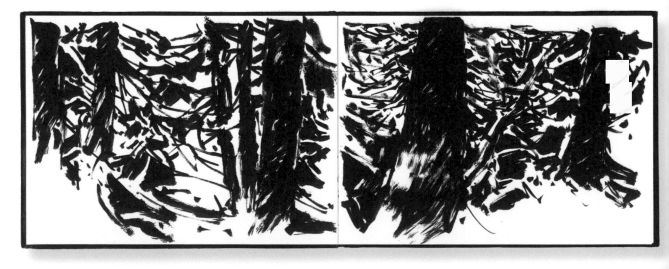

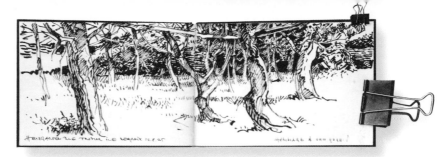

■ **AN INGENIOUS IDEA** You know markers and you know brushes. This brush pen is a symbiosis of both. A great invention. Drawing with this pen is a bit like painting characters of the Far East. You can conjure up the finest lines with it. If you use the brush sideways, it makes thick lines. What's interesting is when the cartridge is nearly empty and gradually threatens to dry the brush out. Then it starts to make some lovely lines that recall the tonal values of charcoal. Working with a brush pen requires a quick, hands-on approach. You have to know what you're doing. The brush pen shown here is equipped with a long-lasting cartridge. The waterproof ink is jet black.

An alternative is the similarly designed colour brush. It contains a flexible, replaceable cartridge, with water-soluble inks in various colours.

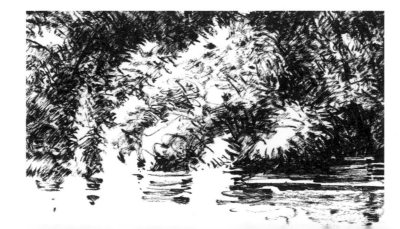

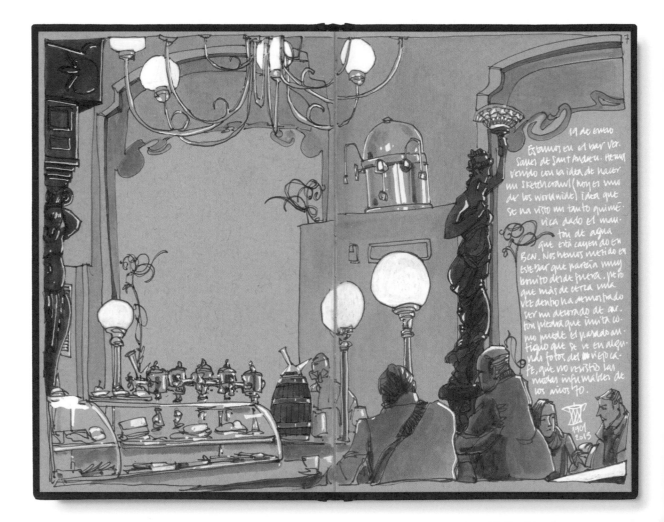

19 de enero

Estamos en el bar Ver-
salles de Sant Andreu. Hemos
venido con la idea de hacer
un sketchcrawl (hoy es uno
de los worldwide) idea que
se ha visto un tanto quimé-
rica dado el man-
tón de agua
que está cayendo en
Bcn. Nos hemos metido en
este bar que parecía muy
bonito desde fuera, pero
que más de cerca una
vez dentro ha demostrado
ser un decorado de car-
tón piedra que imita co-
mo puede el parador an-
tiguo que se ve en algu-
nas fotos del viejo ca-
fé, que no resistió las
modas inflamables de
los años 70.

1901
2013

■ **HIGHLIGHT** When using white paper, it's difficult to get a lamp to look like it's switched on. This only works when very dark tones are drawn or painted around it. It's easier to use opaque white on coloured paper, to "highlight" what is supposed to shine.

The coloured paper serves as a medium tone. Cover the light areas with pure opaque white. By mixing together opaque tempera paints and translucent watercolour paints, you can create subtle nuances. Translucent, transparent surfaces can be achieved with clear watercolours on coloured paper – provided that the paper is sufficiently absorbent.

Here's a tip: first wet the intended area with clear water, let it soak in for a short time and then paint it. This should prevent the colour from blotching.

Artist Miguel Herranz, who is much admired in the Urban Sketchers scene, impressively demonstrates this mixed technique in his coloured drawings. See also tips 41 and 77.

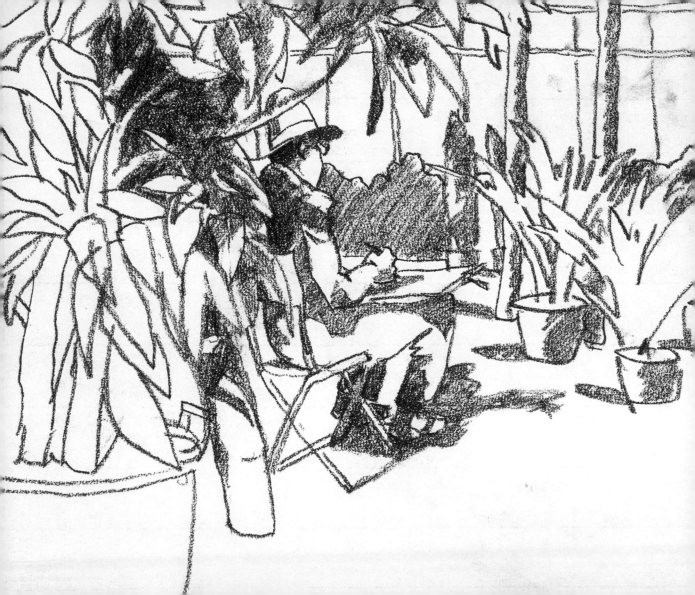

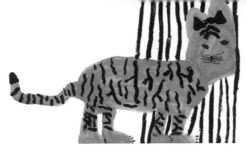
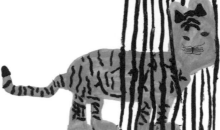

■ **THE LEARNING PROCESS** Children don't usually draw overlapping objects and certainly don't draw one thing on top of the other. If they do, it's from copying someone else or if someone has pointed out the phenomenon of three dimensions to them. This is what happened with eight-year-old Jo-Ella's tiger. It wasn't until someone told her that the feline predator was still running around free, that she realised the effect and, bit by bit, added the cage over the animal. An aha moment that can even surprise inexperienced adults!

Even people attending drawing classes often have to be prompted to try out overlapping and to look for suitable subject matter. Frustration can be avoided by starting with simple subject matter and then dealing with increasingly complex ones. It's great fun to create a three-dimensional space on a two-dimensional sheet of paper.

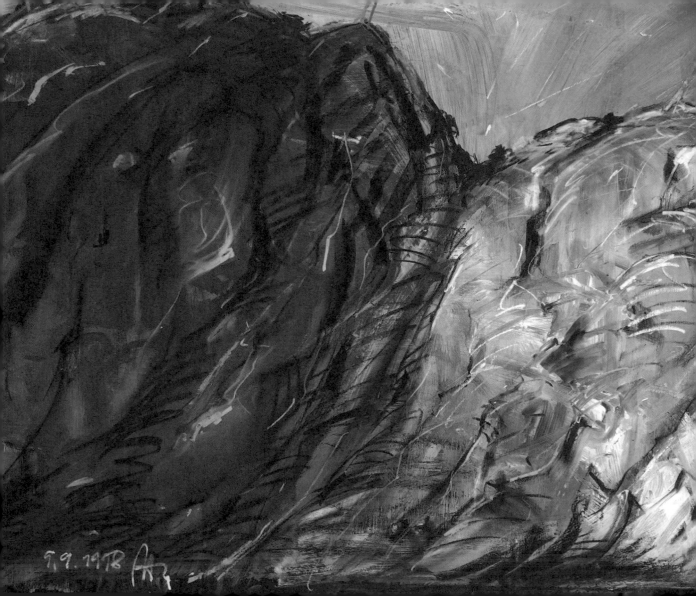

■ **FOUR HANDS** Do you enjoy working with other artists? Yes? Then you might like this suggestion: draw or paint with someone else on the same picture. At the same time! Or one after the other. You start top left, the other starts bottom right. Watch for a while, then get stuck in. Or the other way around. It's lots of fun! So you don't end up breaking friends, you should agree the rules of the game beforehand. For example, whether or not you are allowed to tinker with the other person's work, or whether you can use drawing and painting instruments at random. Of course, there can be no rules regarding the not insignificant question of when a picture is "finished". In my experience, two well-matched artists can quickly come to an agreement. At the end, both will sign it.

You will probably ask what the point in all this is. Think of it as a light-hearted experiment. It demonstrates how two completely different artistic styles can symbiotically combine into a new one, each stimulating the other.

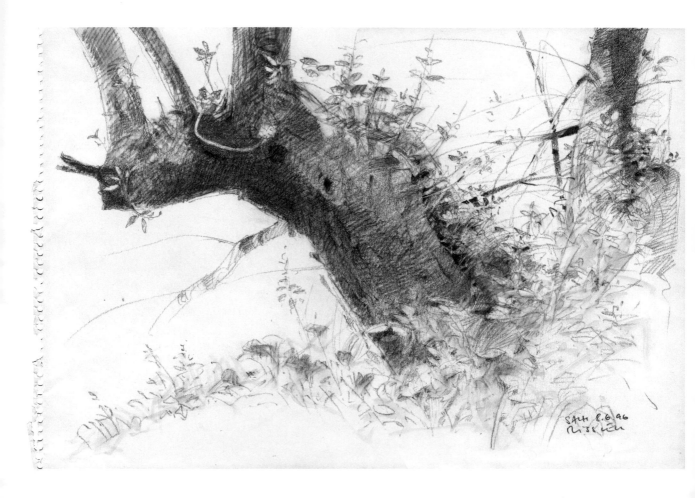

■ **THE MIDDLE IS NOT ALWAYS GOLDEN** It often feels like a drawing's subject matter needs to be positioned in the middle of the page, but that demotes the paper to a mere substrate. The size of the paper is part of the overall effect and can only be seen in the context of the drawing. Sketch little compositions to explore the re-

lationship between the areas taken up by the drawing and the blank spaces. Get to know which drawing-to-blank-space ratios look boring and which become more exciting as a result of extreme contrasts. Effects of light and shade play an important role here. The substance of the subject matter must not be forgotten. It must enter into a symbiosis with the overall design. Just how important all these considerations are can be seen in the etchings of Rembrandt. They are very educational! See also tips 9, 10 and 59.

54

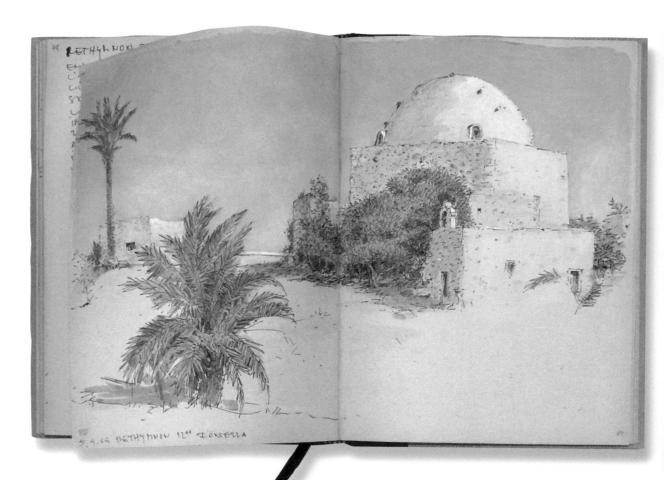

RETHYMNON

80 3.9.99 RETHYMNON 12TH FORTEZZA

■ **RECYCLING** Sand-coloured sketch paper is not a bad choice for a summer art field trip to the Mediterranean, as long as the colour of the ground is more or less the same as that of the paper. Recycled paper has visible inclusions of wood fibres or paint residue. Finding this sort of paper in a book is a matter of luck. Alternatively, you can make your own sketchbook. Almost every major city offers bookbinder classes where you can make your own book out of recycled paper. Or you can collect sheets of recycled paper and take them to a bookbinder, for a custom-made thread-stitched sketchbook with cover.

Recycled and coloured paper have a great advantage over white paper: their base colour makes it quicker to colour lighter and darker areas when drawing with richly coloured pencils, opaque white paint and tempera.

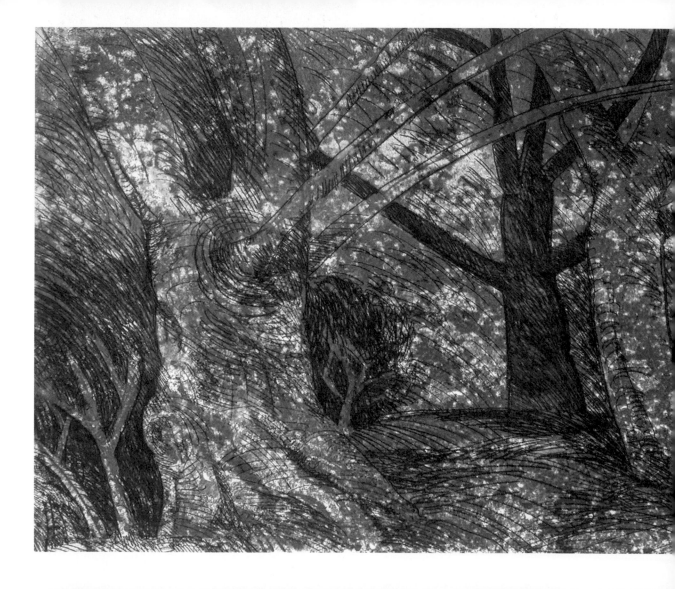

■ **BLIND PRINTING** The monotype technical process can briefly be described as follows: a piece of paper is placed very carefully and without pressure on a painted glass plate. Draw on the visible side of the paper. You can use any type of drawing instrument. The monotype is created on the underside – a one-off print. The result is only visible when the paper is lifted off the painted surface. The best results are achieved with offset inks and very thin book-printing paper. Good rollers and two glass plates for smoothing out the paint guarantee good prints. Prof. Jörg Osterspey's examples demonstrate that monotypes can be developed into multi-colour prints. On a side note: there are always two originals. The drawing on the back of the monotype and the one-off print itself!

For offset printing inks, you have to work with solvents. There are alternatives, but they don't produce quite as good results. You can experiment with water-soluble linoleum inks or acrylic paints. To the latter you can add a retarder, which prevents the paint from drying too fast.

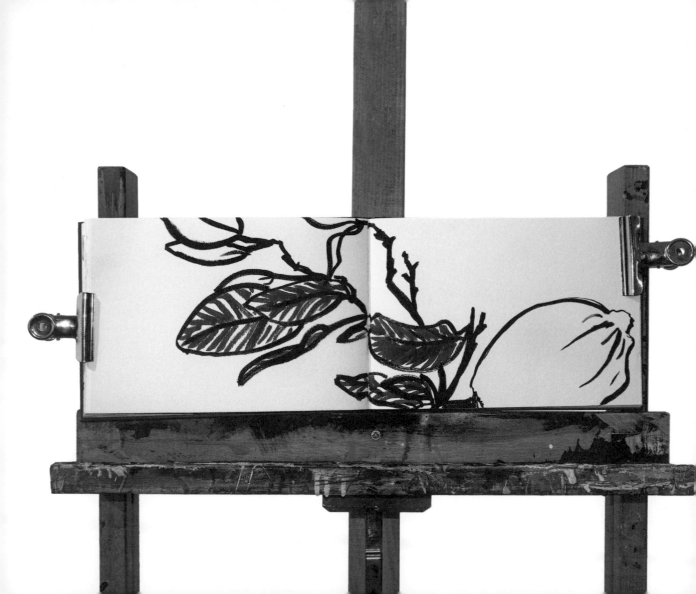

■ THERE ARE TWO SIDES TO EVERYTHING This goes for sketchbooks, too. Its single pages are not two separate sheets to be worked on, but a cohesive design space. The binding, which divides the two sides, doesn't thereby disrupt them. Quite the contrary.

For example, pictorial elements may be placed in such a way that both sides clip together. As with an undivided piece of paper, there are a variety of things that can be done to make a double page composition more exciting. Bold framing or cut-outs, diagonal divisions, trellised spaces, contrasts of light and dark, interesting textural (mis)matches, the "introduction" of outside subject matter into the design format, disappearing off the edge or out of the picture, dialogues taking place over the binding stitches and much more. So, if you're used to always placing your subject in the middle of a single sheet of paper, try boldly placing it somewhere else. This will make the whole double page area in the sketchbook become a part of the overall design. See also tip 58.

57

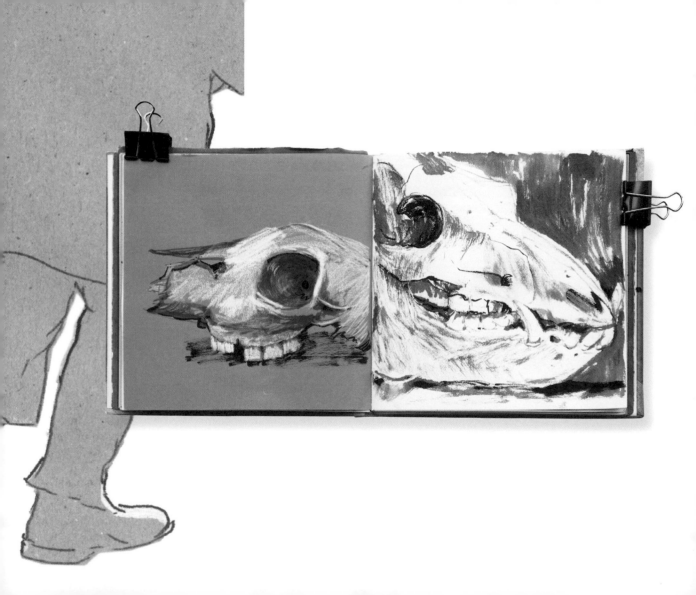

■ COME OUT OF YOUR CORNER! It is quite likely that some mid-19th century Western artists held their heads in their hands when they saw Japanese woodblock prints for the first time, thinking, "Why didn't WE think of that?" Van Gogh wrote to his brother Theo that in Paris, one could only see with Japanese eyes from now on. The nature of Japanese image composition was so new that he and others immediately adopted this approach. Two-dimensional image planes, slender formats, trellised spaces, bold overlaps, and much more became design tools that are still used in all visual arts.

As the examples on these pages demonstrate, the area of an image can be designed so differently to usual. Using decisive framing, with the subject "coming in" or "going out", or by contrasting textures, the layout not only becomes more exciting in terms of form, but also in terms of the meaning that wants to be communicated. Not everything has to be depicted within the frame. Some things are beyond the conceivable and give wings to the imagination. So it's not surprising that illustrators of children's picture books, for example, use this design approach. See also tips 57 and 65.

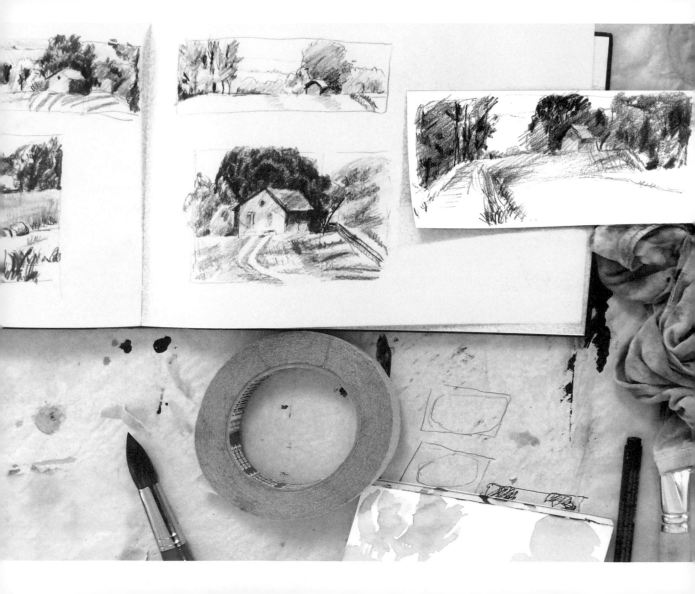

■ **DRAWING STAMPS** Every drawing needs a frame. So make the following preparations: start off by doing some postage stamp-sized composition sketches before you go ahead and start drawing in the top left corner of a larger sheet, only to find you don't have enough space. This is also a quick way to see the overall structure of the image, so you can get your bearings on the larger piece of drawing paper. It's also handy to document these composition attempts in your sketchbook. They will be there ready and waiting for you, if you need to refer to them later. You can also record different perspectives with a digital camera. Save these alternative versions and compare them. This is how you train your feel for an exciting composition. See also tips 9, 10 and 54.

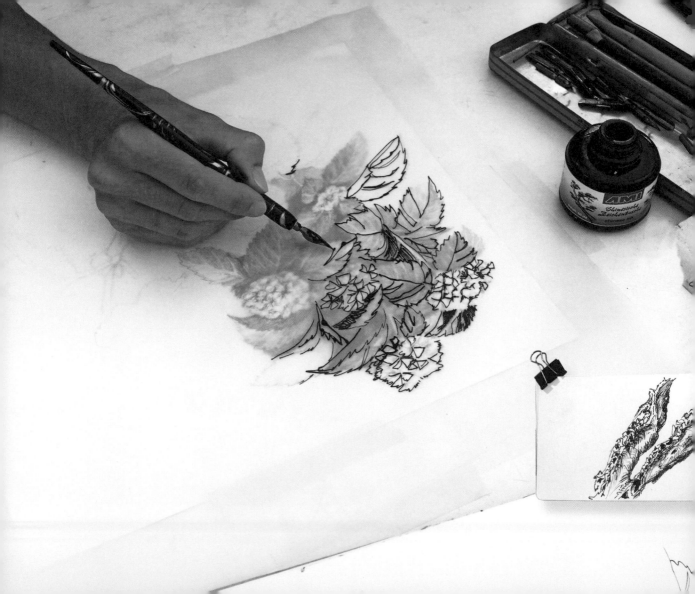

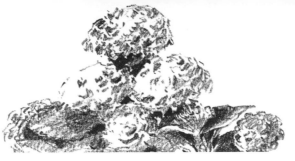

■ **SEE IT THROUGH** Take one of your drawings that you think should have been more spontaneous. Lay a not-too-thin piece of tracing paper on top of your artwork and fix both sheets together with adhesive tape.

Don't use a photo as a template. Why? You are "well read" in drawing something sitting in front of you. It isn't strange to you. This is an advantage that shouldn't be underestimated – it can really give your drawing more spontaneity. You can trace the translucent template with a drawing instrument that flows well. The faster and less prudently you do that, the better. Try out different pens to find out which ones work best for you. If you are satisfied with the results after a few goes, try drawing without the tracing paper.

Using a similar method, you can also try out how your drawing might look coloured in. Place some tracing paper over your artwork and colour in the desired sections.

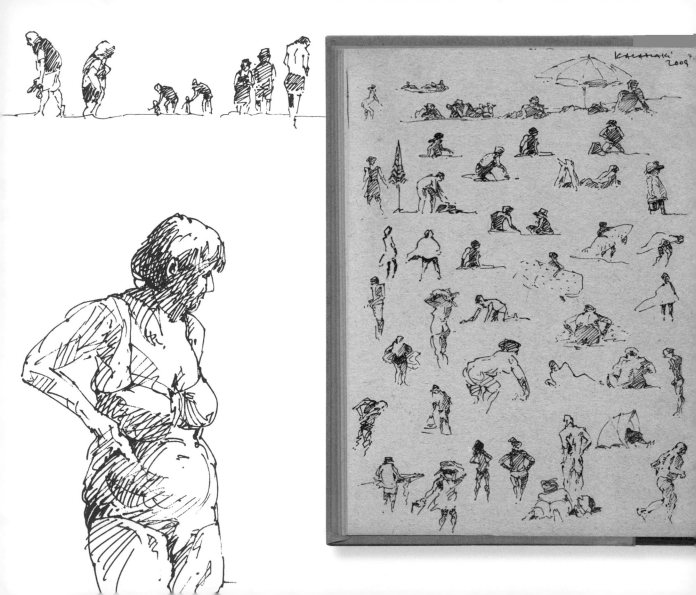

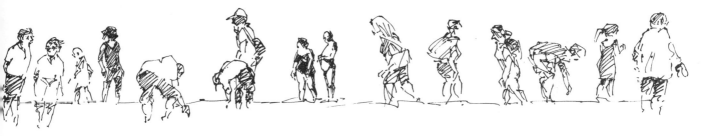

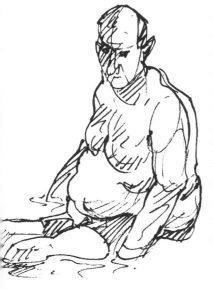

■ **FIT FOR A KING** The supreme discipline of Fine Arts is drawing, with the crowning glory being the depiction of the human body. The need to master anatomy in drawings is as old as art itself. But it's not easy.

Children start drawing people early on, teenagers labour over comics and adults attend nude drawing classes at academies and community colleges and in countless independently-organised groups.

In these groups, you often sign up for very short exercises that only last a few minutes, where the model pauses to pose a moment or actually moves. Sketching in these conditions can be terribly frustrating, but it is one of the best drawing exercises you can do. The visual experience you get from it is far more important than what ends up on the paper.

So, take figure drawing classes as often as you get the chance. Stop taking photos – draw "live action" instead!

By the time you're sitting on the beach wearing sunglasses, with your sun hat pulled down over your forehead, armed with a sketchbook ready to draw the tourists, you will benefit from it. Pens that write smoothly and quickly are ideal.

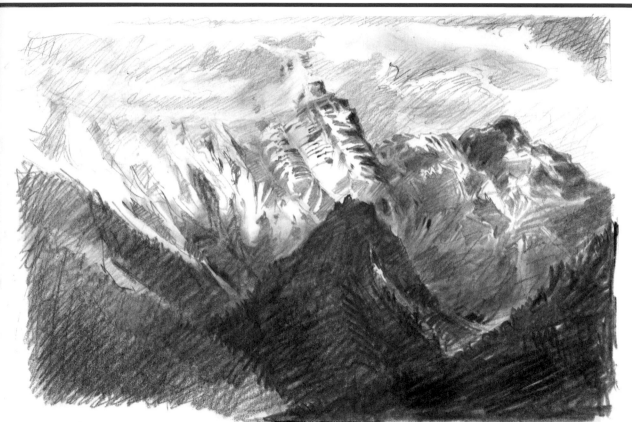

WATZMANN VON HOCHSCHWARZECK GESEHEN 7.6.2018

■ **ALL CREASED UP** If you want to learn how to draw folds in material, be sure to try tonal values first. Pay attention to smooth transitions from light to dark and shadows that have a clear outline. A particularly good way to achieve this distinction is by using a bright lamp to put a spotlight on a plain white cloth, for example.

Draw with very soft pencils, the best is 8B. Contours are created just by putting varying tonal values next to each other. The barely visible guidelines that you drew to sketch your subject disappear once you start shading.

Mastering the way fabric folds, without using borderlines, makes it much easier to draw similar subject matter. When you're sitting in front of a rocky cliff by the sea or in the mountains, you will see why. When you're drawing a nude model or someone's portrait, too, you'll have much more success if you don't use borders between the different shades.

It is of utmost importance that you look at surfaces when you draw, because then you will also be able to master shading them using a felt-tip pen, an ink roller, or other drawing instrument.

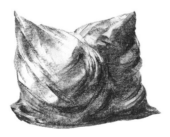

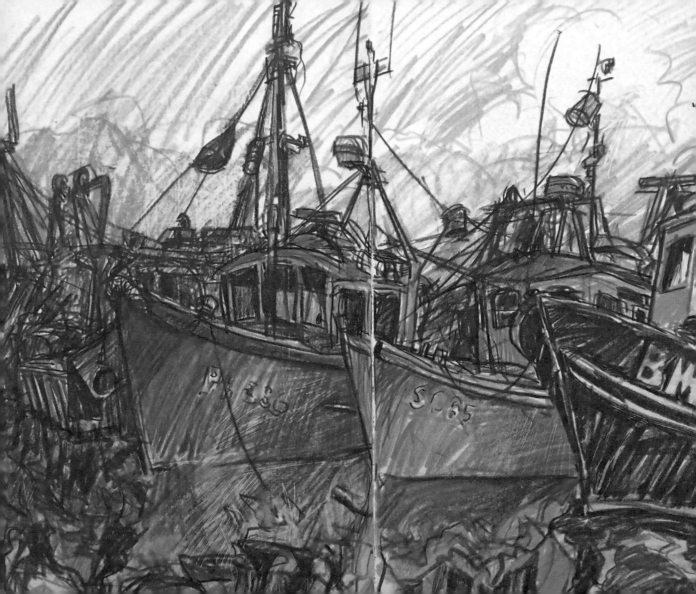

■ **NOT JUST FOR KIDDIES** Pencil crayons are standard items in a school pencil case, but they can also unfold their special magic in the hands of a professional artist. The drawings in the sketchbooks of my former student Christian Barthold are a fantastic demonstration of this.

The range of colourful pencil crayons that are available is mind-bogglingly wide. When choosing which ones you need, you should have a clear idea of what sort of drawing they are going to be used for. Crayons range from creamy soft to pretty hard. The latter are just right for small formats and for precise drawings. All varieties can be mixed together. But a note from experience: always draw with hard pens over soft! The quality of the paper also plays a role. If it is too soft, the paper "fatigues" quickly. On paper that is too hard, the crayon marks don't hold fast.

As a rule, pencil crayons are set into wood. Slightly thicker pencils, with leads up to 10 mm thick, are more comfortable to hold. Some of these can be washed generously with water. If there is no wooden casing, they are called wax crayons. The flat sides of square crayons are great for colouring and drawing over borders.

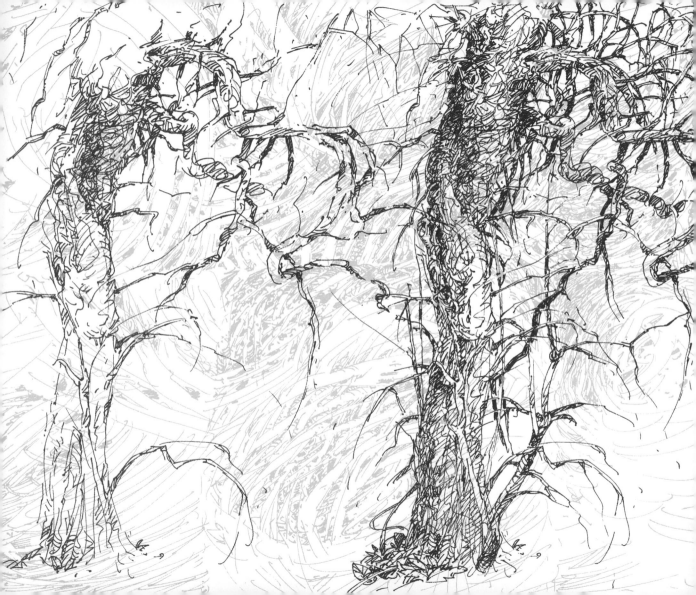

■ STORAGE CAPACITIES When you draw a lot in nature, you create a sort of herbarium that sleeps on your cerebral hard drive and can be downloaded on demand at any time. It is a treasure trove that makes drawing in the field easier and easier until your hand starts to move over the page without much thought. When it starts to "flow" and the drawing appears almost by itself, it can unleash great feelings of happiness. On top of this, being able to detach yourself from the subject matter while you are sitting there, is especially satisfying.

As you gain experience, you realise that you are not a slave to the subject matter. You design your picture the way you like it. Using all the material you have stored in your head, you can add what you think is good for your drawing. You can leave out the bits you don't want. It's your drawing, make it *your* picture.

Drawing nature without being surrounded by it is another challenge. You'll be able to see how useful your sight training in nature was from the results you get. The better you train your eye while out in the field, the freer you will be to interpret natural forms. This will be expressed in every single line you draw.

■ **INSPIRATION FROM THE FAR EAST** You come home from shopping. You discover that the goods you've bought have been packaged in Japanese woodblock prints – they are originals and of great artistic quality. You start collecting them. You and your artist friends are so fascinated by the artwork that you want to try out this hitherto unknown visual concept. This triggers a movement that turns the art scene upside down.

That's what happened circa 1870. Working in a Japanese style became all the rage and it still echoes today. Image trellising is one of the visual concepts that painters, cartoonists, illustrators, draughtsmen, photographers and cameramen still use today – artist Jörg Hülsmann being one of them. He showcases this in his great works based on Italo Calvino's book "The Invisible Cities". The magic word is Japonism. Check it out!

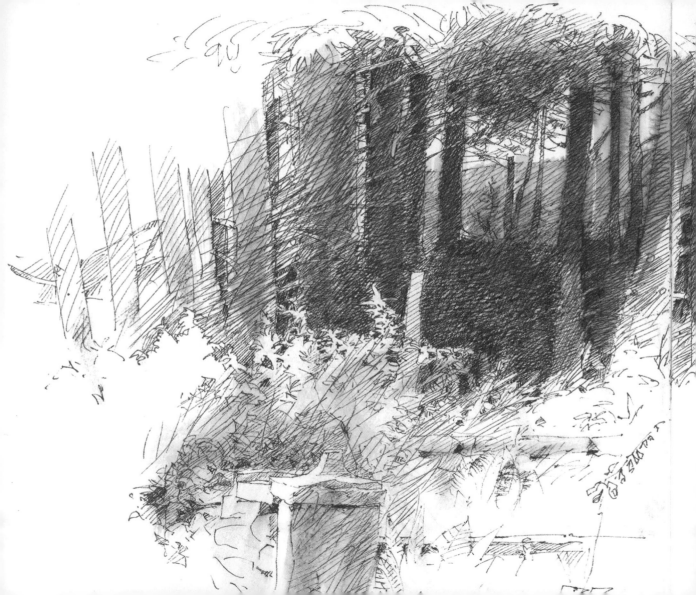

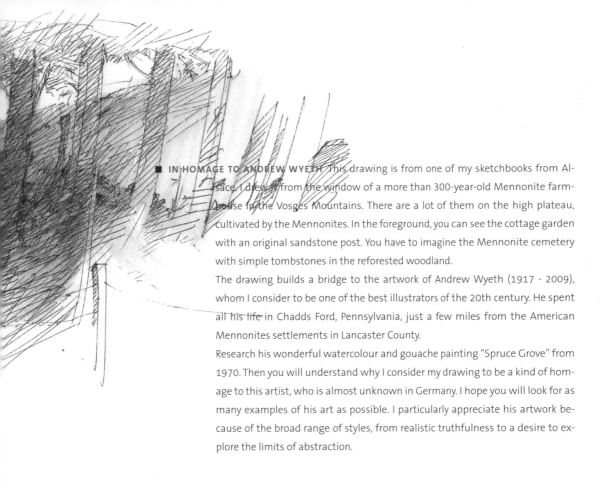

■ **IN HOMAGE TO ANDREW WYETH** This drawing is from one of my sketchbooks from Alsace. I drew it from the window of a more than 300-year-old Mennonite farmhouse in the Vosges Mountains. There are a lot of them on the high plateau, cultivated by the Mennonites. In the foreground, you can see the cottage garden with an original sandstone post. You have to imagine the Mennonite cemetery with simple tombstones in the reforested woodland.

The drawing builds a bridge to the artwork of Andrew Wyeth (1917 - 2009), whom I consider to be one of the best illustrators of the 20th century. He spent all his life in Chadds Ford, Pennsylvania, just a few miles from the American Mennonites settlements in Lancaster County.

Research his wonderful watercolour and gouache painting "Spruce Grove" from 1970. Then you will understand why I consider my drawing to be a kind of homage to this artist, who is almost unknown in Germany. I hope you will look for as many examples of his art as possible. I particularly appreciate his artwork because of the broad range of styles, from realistic truthfulness to a desire to explore the limits of abstraction.

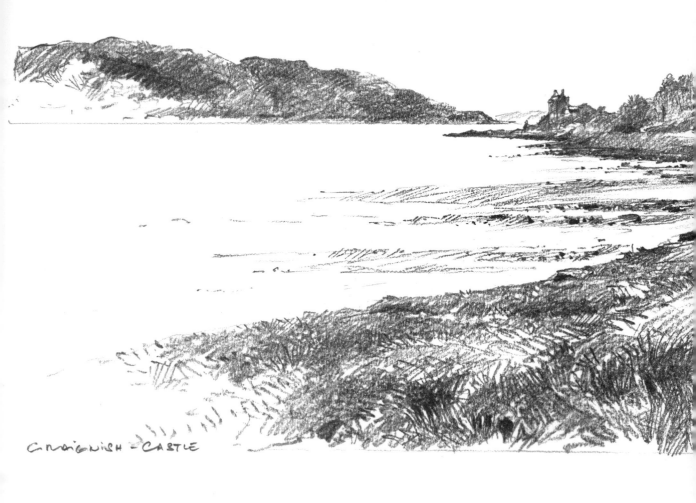

CRAIGNISH - CASTLE

4. 5. 14 D'ÉCLÈN

■ **AT EYE LEVEL** A phenomenon that is frequently observed in interior and landscape drawings is that the horizon is turned upwards. The images give the impression that they are viewed from an elevated, even bird's-eye view. Drinking glasses are often drawn like this, with rims that are depicted more by the imagination than by close observation. This is reminiscent of children's drawings. They think that the rim of a glass is an open circular shape and that the base is on a flat table. It is also interesting to compare this with a wood engraving by Urs Graf, just before the central perspective was rediscovered in Italy circa 1500 AD.

Here you can see how it relates to the drawing of a bay in Scotland, left. To keep the horizon at eye level, the oval shape of the bay must be drawn very flat. A proven method of estimating the distance of certain points is to hold a pencil with an outstretched hand in front of your subject matter. A course on perspective drawing or a good textbook will help you overcome the first few difficulties.

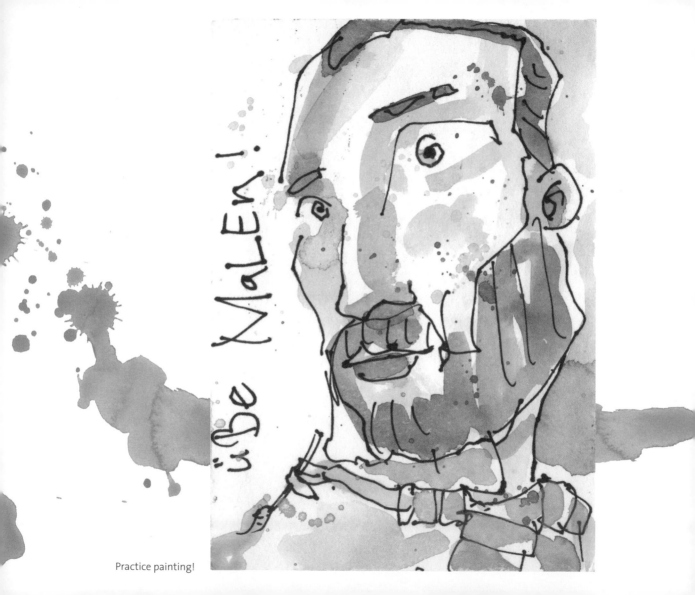

üBe MaLEn!

Practice painting!

■ **PRACTICE PAINTING!** This postcard was sent to me by a student, Christian Felder. He's good at drawing and is a talented painter. He knows that I prefer to draw and that I wouldn't call myself a painter. Nevertheless, the rallying cry is absolutely justified. Both techniques are related in many ways. And, as this card illustrates so impressively: together they make a wonderful combination. It's best to think of drawing and watercolour painting as being independent of each other. Painting within the lines would have taken away the artwork's original spontaneity. Coloured drawings work particularly well with sketches that are created on the road, or with those that you don't have much time to spend on. You can add paint when you arrive at your destination, which is why you should always have a travel-sized watercolour set in your luggage.

A simple but handy alternative to normal watercolour brushes are water brush pens. These plastic brushes have a water tank attached. Fill up a handful of them with the most important colours, and the cup and paint box can stay at home.

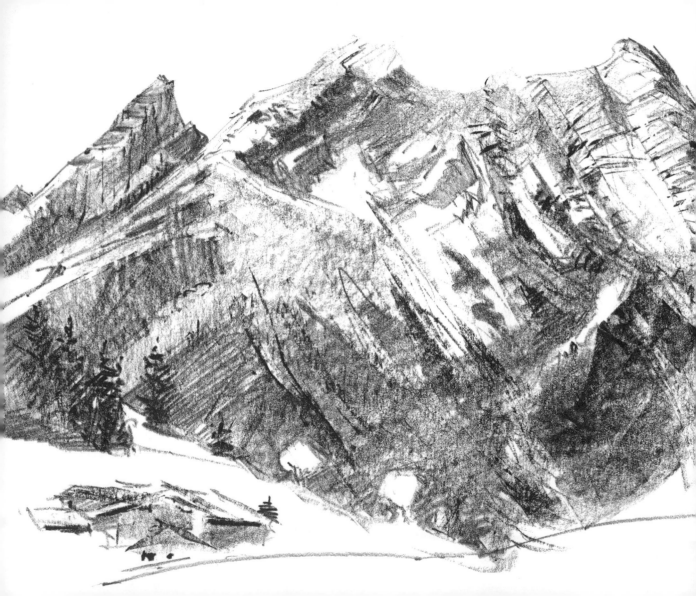

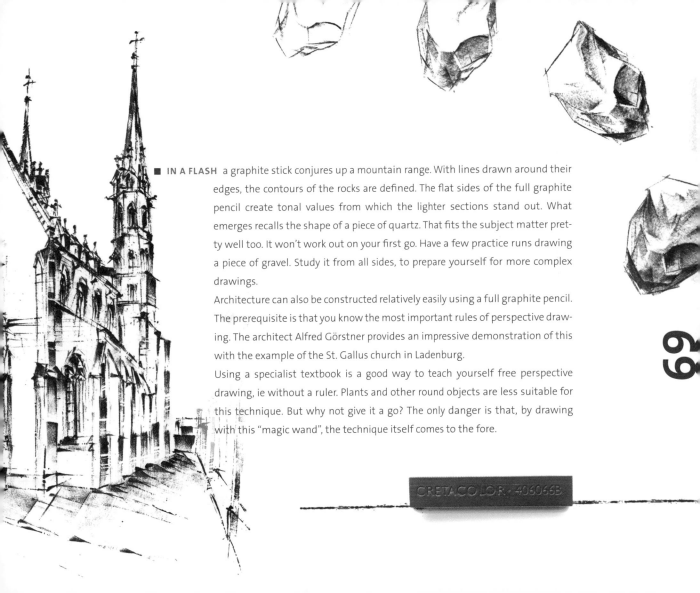

■ IN A FLASH a graphite stick conjures up a mountain range. With lines drawn around their edges, the contours of the rocks are defined. The flat sides of the full graphite pencil create tonal values from which the lighter sections stand out. What emerges recalls the shape of a piece of quartz. That fits the subject matter pretty well too. It won't work out on your first go. Have a few practice runs drawing a piece of gravel. Study it from all sides, to prepare yourself for more complex drawings.

Architecture can also be constructed relatively easily using a full graphite pencil. The prerequisite is that you know the most important rules of perspective drawing. The architect Alfred Görstner provides an impressive demonstration of this with the example of the St. Gallus church in Ladenburg.

Using a specialist textbook is a good way to teach yourself free perspective drawing, ie without a ruler. Plants and other round objects are less suitable for this technique. But why not give it a go? The only danger is that, by drawing with this "magic wand", the technique itself comes to the fore.

69

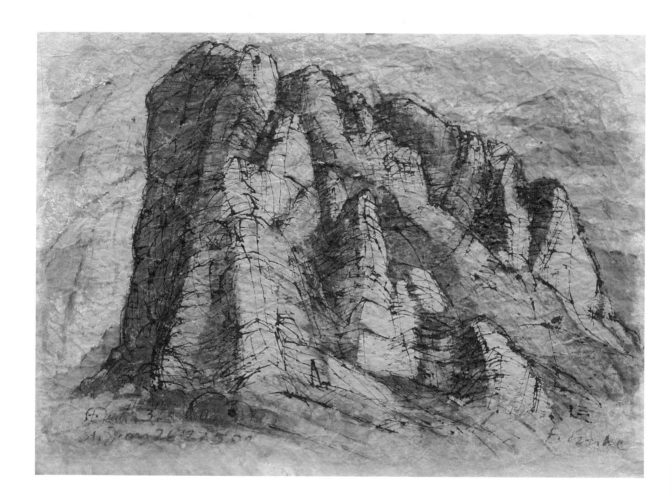

■ **FOLDING MOUNTAINS** Imagine you are sitting in front of a huge limestone massif and want to draw it. The individual groups of rock are covered in a web-like craquelure. How do you meet this graphic challenge? Certainly not by drawing every last hairline crack, because the effort with which it is drawn would be noticeable on each individual line. Moreover, it's easy to lose your focus and no longer know which bit you're working on.

Here's *one* of many possible suggestions on how to tackle the mountain: the night before, crumple up some packing paper and dip it in emulsion paint before flattening it out. The next day, when it's dry, the paper will be slightly wrinkled and no longer flexible. Preparing it in this way gives you an ideal substrate for washed pen drawings, since it already has the visual characteristics of rock and therefore encourages free interpretation of the subject matter.

The sculptor Prof. Eberhard Linke drew the limestone cliffs that stand over the village of St. Jean de Buèges in southern France.

■ **SUCCESS IS NO ACCIDENT** Talent alone is not enough. Anyone who has a good ear for music still has to practice if they are to make a career out of it. It's the same with drawing. A gift is an invitation to use it, responsibly. The illustrations by Mandy Schlundt shown here on the left didn't just fall from the sky. They are the result of many years of practice; she didn't draw them at the beginning of her studies. The far-from-simple scraping technique was new to her. But with years of drawing practice behind her, she was able to make the right decisions in this unfamiliar terrain.

The scraping technique worked best on a completely black-exposed, fixed repro sheet. Unfortunately, this photosensitive film is hardly used in the printing industry these days. Scraperboards are readily available in shops, however. They are coated with a mixture of white chalk and binders, with a layer of deep matte black printed on top. Fine lines and even slightly transparent tones can be scraped into this surface with an etching needle, a scalpel or with a razor blade.

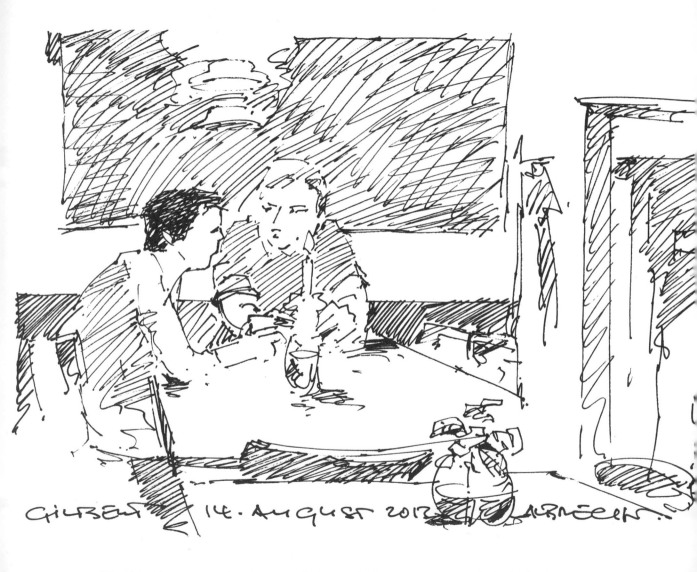

GILBERT · 14. AUGUST 2012 ... LABROECK

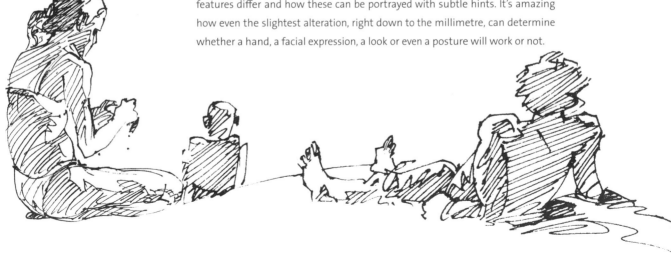

■ **THE EASIEST THING IS ALSO THE MOST DIFFICULT** If you want to be able to draw people when you're out in public, using only a few easy strokes and avoiding stereo-typed uniformity, it takes a lot of prior training. Take every opportunity you get to draw portraits, nude models and people sitting peacefully. Gradually shorten the time you spend on it. Use pens that you can't rub out. You will make little progress drawing from photos, because you don't see people's bodies in three dimensions. A good textbook can help, but it can't replace drawing people while they're sitting in front of you. Over time, you will start to notice how models' features differ and how these can be portrayed with subtle hints. It's amazing how even the slightest alteration, right down to the millimetre, can determine whether a hand, a facial expression, a look or even a posture will work or not.

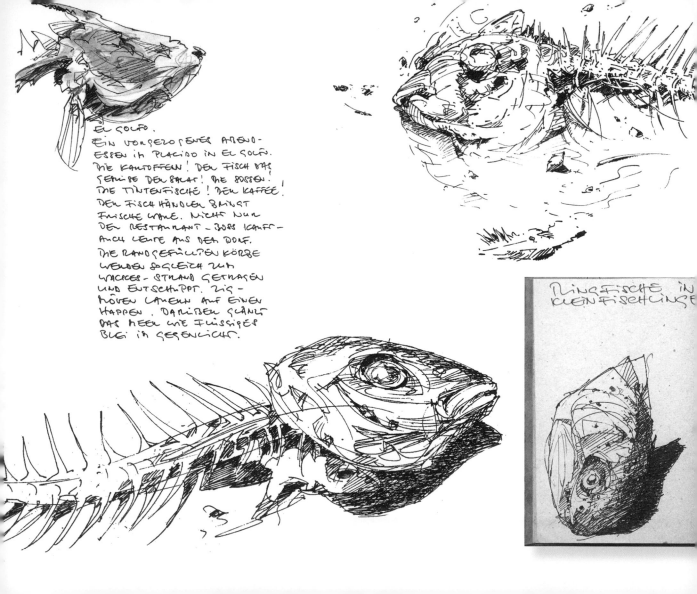

EL GOLFO.

EIN VORGEZOGENES ABEND-
ESSEN IN PLACIDO IN EL GOLFO.
DIE KARTOFFELN! DER FISCH DAS
GEMÜSE DER SALAT! DIE SOSSEN!
DIE TINTENFISCHE! DER KAFFEE!
DER FISCHHÄNDLER BRINGT
FRISCHE WARE. NICHT NUR
DER RESTAURANT - JUSS KAUF-
AUCH LEUTE AUS DEM DORF.
DIE RANDGEFÜLLTEN KÖRBE
WERDEN SOGLEICH ZUM
WACKER - STRAND GETRAGEN
UND ENTSCHLIPPT. ZIG-
MÖVEN LAUERN AUF EINEN
HAPPEN. DARÜBER GLÄNZT
DAS MEER WIE FLÜSSIGES
BLEI IM GEGENLICHT.

RINGFISCHE IN
KLEINFISCHLINGE

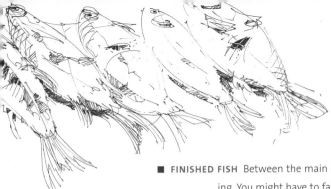

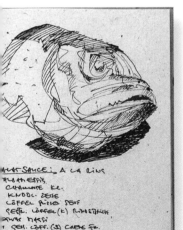

■ **FINISHED FISH** Between the main course and dessert, there's not much time for sketching. You might have to fall into the waiter's arms to stop him from clearing the table of all the pretty things you want to draw. It's a pity to bin them. Well, until you've finished drawing them at least.

Take along some pens that glide easily over the paper, a sketchbook that doesn't take up half the table, a tolerant companion and you're all set. If you draw your sketch in the restaurant, but colouring it in would distract you from paying attention to the conversation, you can catch up later in your hotel room or at home. When using watercolour paints, you need suitable paper. Or you take a set of brush pens with you. But beware: depending on the quality of the sketchbook, some paints might penetrate the paper. You can keep a sketchbook like a diary, so you can stick a business card in it alongside your drawings, add a restaurant review or maybe a recipe the chef lets you in on.

73

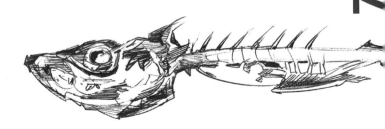

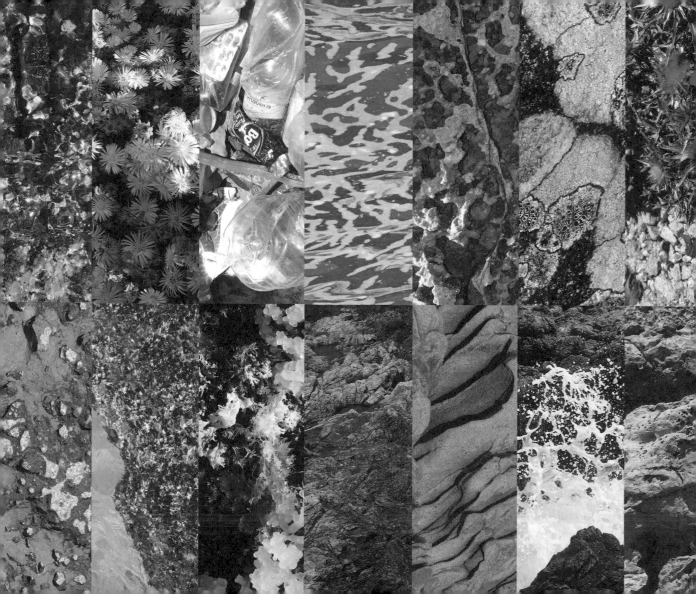

■ **SEARCH FOR TRACES** When we talk about drawings, we generally think of artwork that is composed of singular lines. But there's so much more to drawing than that! Drawings can also consist of tonal values that appear from a thousand single strokes, from contour and parallel hatching, or from a variety of structures of varying density and brightness.

Textures are the most interesting and graphically demanding, because they describe the surface qualities of materials. For example, if you want to draw a tree, you will have to tackle the characteristics of the leaves and the bark, and find identifier shortcuts that achieve this effect. So you etch minimalist, individual forms that represent a complex subject matter when seen together. Depending on how closely they are placed together, you can create a three-dimensional effect using bright patches or shading.

Sensitise your perception by searching for interesting surfaces with a camera. Study drawings by the art masters of history. This will help when you want to draw the characteristics of a certain kind of surface texture in detail when you are out and about. See also tips 28, 29 and 105.

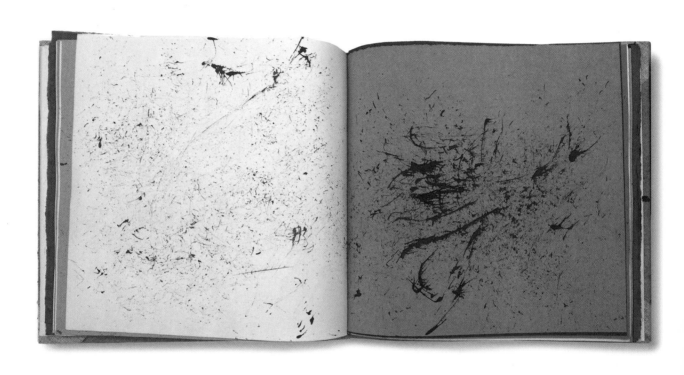

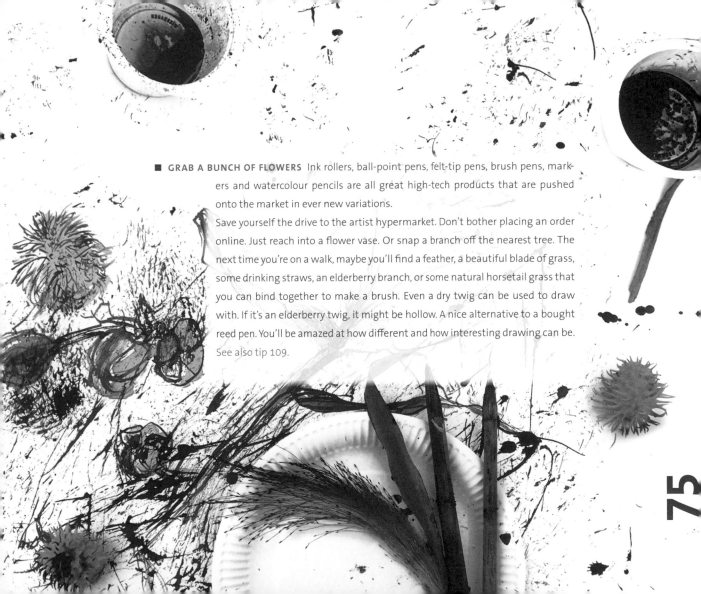

■ **GRAB A BUNCH OF FLOWERS** Ink rollers, ball-point pens, felt-tip pens, brush pens, markers and watercolour pencils are all great high-tech products that are pushed onto the market in ever new variations.

Save yourself the drive to the artist hypermarket. Don't bother placing an order online. Just reach into a flower vase. Or snap a branch off the nearest tree. The next time you're on a walk, maybe you'll find a feather, a beautiful blade of grass, some drinking straws, an elderberry branch, or some natural horsetail grass that you can bind together to make a brush. Even a dry twig can be used to draw with. If it's an elderberry twig, it might be hollow. A nice alternative to a bought reed pen. You'll be amazed at how different and how interesting drawing can be. See also tip 109.

75

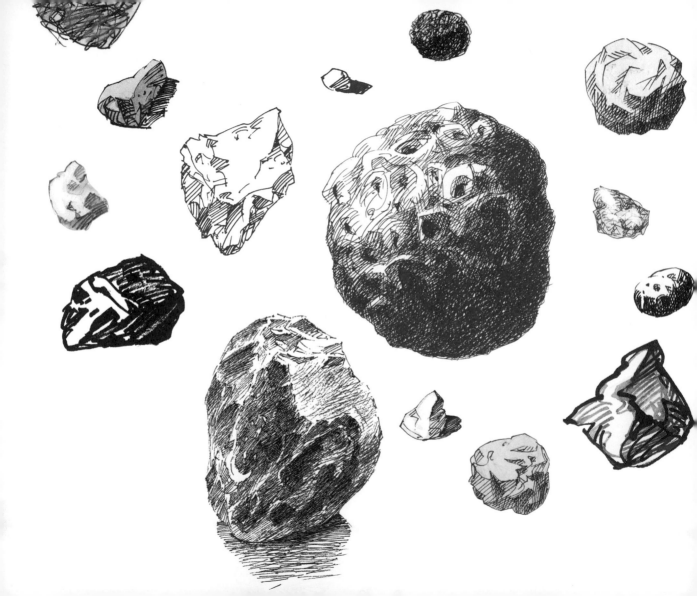

■ **PRACTICE, PRACTICE, PRACTICE** It's impossible without it.

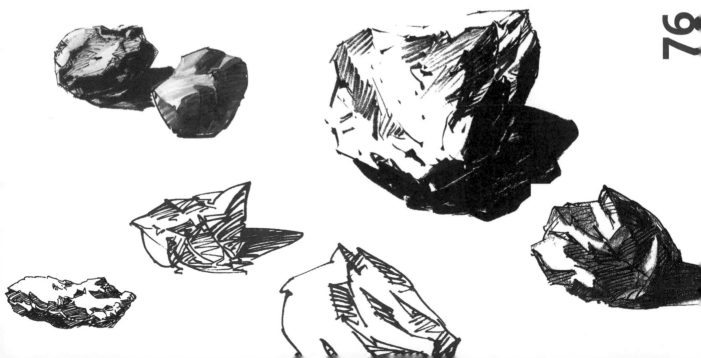

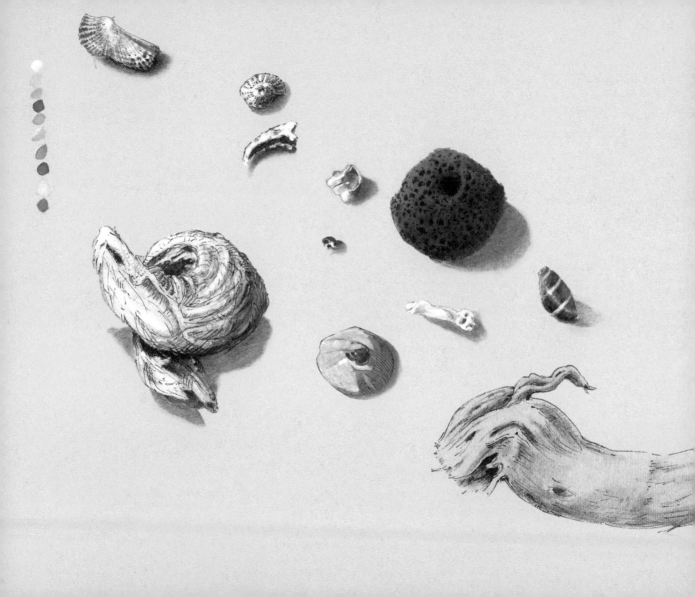

AUA!
← SOLCH EIN SEE-
IGELSTACHEL SASS
MIR TAGELANG IN
MEINEM LINKEN
RINGFINGER. MIT
SPECK UND HEILSALBE *
KAM ER SCHLIESSLICH
WIEDER ZUM VORSCHEIN
* VON WELEDA!

■ **BEACH BEAUTIES** Driftwood made into wonderful shapes by the sea, fragments of mussel and snail shells, crab scissors, porous lava stones, shells of sea urchins and smooth shards of glass — all these little things can be used to decorate your holiday sketchbook. Using a pencil, familiarise yourself with their form. After that you'll manage a few easy drawings with a swift pen. Or you could challenge your patience and try to portray these beauties as vividly as possible. If you have a sketchbook with coloured paper, use a pencil to create the shape of the object, especially on the shaded areas. On top of that, apply watercolour to create the ground colour. Finally, add opaque white to the parts you want to highlight. Here's a special tip for drawing shiny objects on coloured paper: start by priming the surfaces with diluted opaque white paint.

See tips 82 and 51.

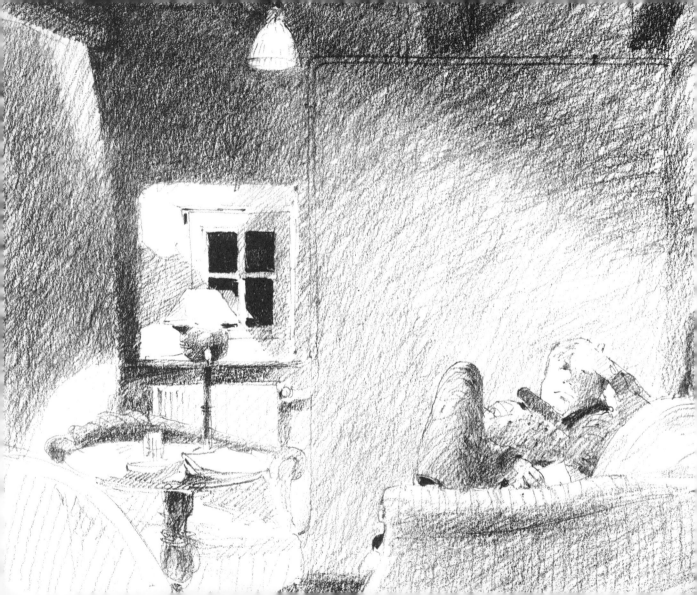

■ **PARALLEL WORKS BEST** Artists use hatching drawing techniques in lots of different ways. Everyone has their own style. Leonardo da Vinci mostly drew with his left hand. So you can really see how his hatchings were made by lines drawn from top left to bottom right. Albrecht Dürer was a master in the art of form hatching. They help to make objects look more rounded. It takes some concentration to get the lines to curve downwards or upwards in parallel with each other. Hatching is not so noticeable when the lines are made with a loose hand or when they produce tonal values.

Crosshatching looks very technical. In dense areas, however, this impression is lost. Multi-layer parallel hatching becomes more homogeneous when the layers of the lines are drawn at a shallow angle to each other. The darker the tonal values, the less the direction of the lines plays a role.

My advice: quickly drawn hatchings look better than those drawn carefully. So it is best to practice hatching on at least A4-sized paper. Using an ink roller pen is great for this! See also tip 46.

■ **SEISMOGRAPHIC DRAWING** Find something that vibrates. If need be, you can even lay a piece of paper on your teetering leg and let a pen dance around on it. The idea for the drawing on this page was born on a long bus ride down bumpy roads. Heavy drawing instruments work best, as you can make a line using their weight alone. You can steer the pen in certain directions: for example, to make some areas denser than others, or to rhythmically order the structures. Or leave it entirely to chance. Another method is drawing slash marks (see left). Use a pen that still has plenty of ink left to strike a robust piece of paper. Ink roller pens, goose feather quills, pens, wax crayons, even a tuft of grass – anything that can be used with ink is suitable. Why do all this? It makes your eyes more cognisant to structure. And: you let your rational mind have a break and let the material take control of the drawing.

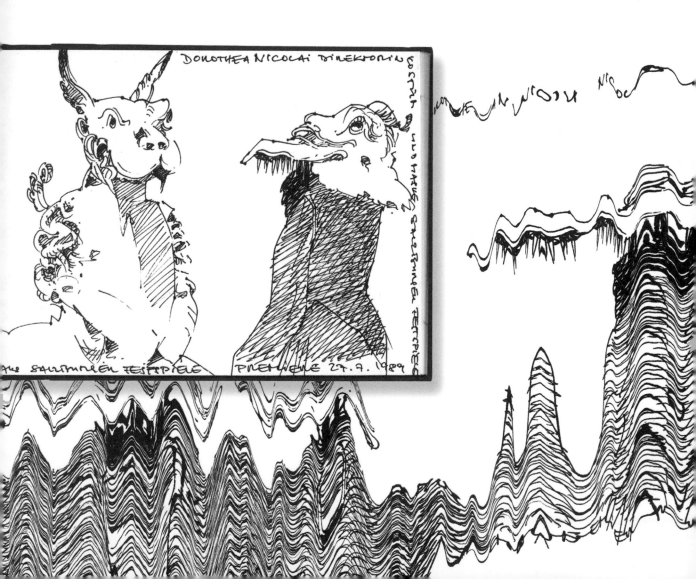

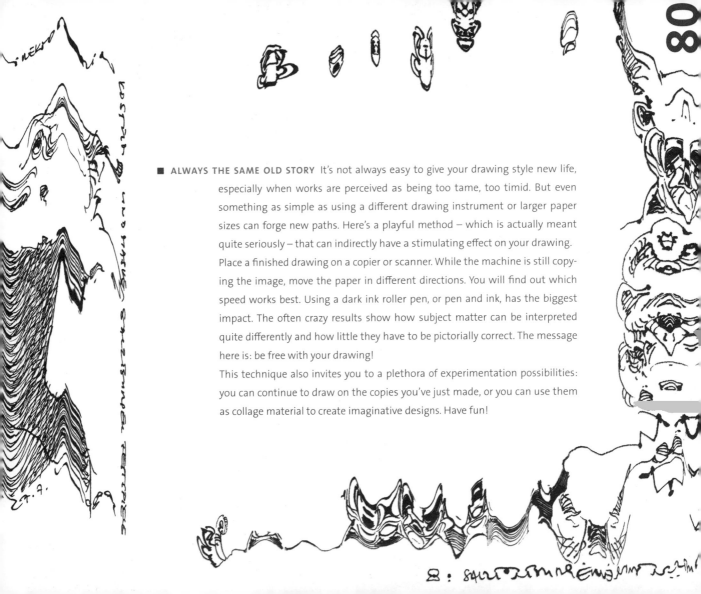

■ **ALWAYS THE SAME OLD STORY** It's not always easy to give your drawing style new life, especially when works are perceived as being too tame, too timid. But even something as simple as using a different drawing instrument or larger paper sizes can forge new paths. Here's a playful method – which is actually meant quite seriously – that can indirectly have a stimulating effect on your drawing. Place a finished drawing on a copier or scanner. While the machine is still copying the image, move the paper in different directions. You will find out which speed works best. Using a dark ink roller pen, or pen and ink, has the biggest impact. The often crazy results show how subject matter can be interpreted quite differently and how little they have to be pictorially correct. The message here is: be free with your drawing!

This technique also invites you to a plethora of experimentation possibilities: you can continue to draw on the copies you've just made, or you can use them as collage material to create imaginative designs. Have fun!

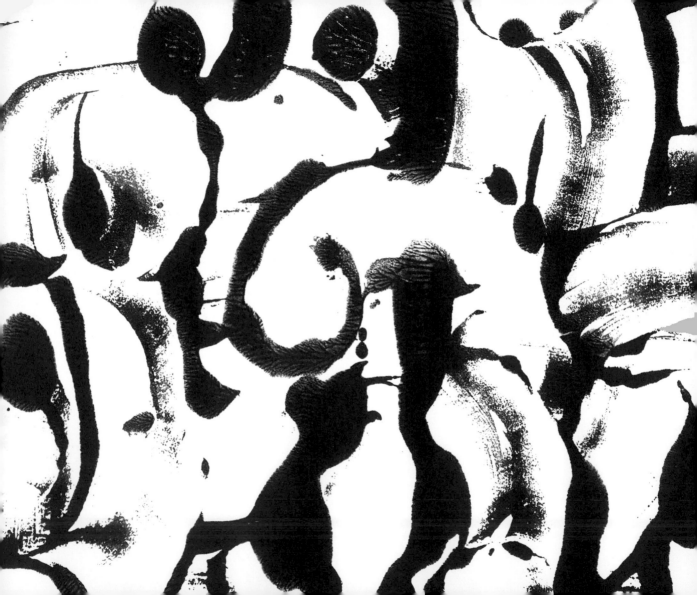

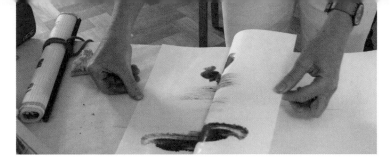

■ **DRAWING WITH PASTE** The play on positive and negative elements in the picture can be complemented by a fitting experiment. What you need: wallpaper paste, a bucket, a narrow drinking glass, acrylic paint, a glass for mixing, a flat brush and good quality paper. Mix the paste with water until creamy and without lumps. Spread it on the paper and then add a coat of paint. Then place the narrow drinking glass firmly onto the paste-acrylic mixture you've just painted, with the opening upright, and push it over the paper with generous movements. You can use the result of this as a printing block: cover it with a new sheet of paper and press down on it gently with the palm of your hand. Now pull the two sheets evenly apart. This is the first copy – a sort of monotype print. Both sheets of paper can be stuck back together again until the paint runs out. You can do multi-colour prints and overprints with two different "printing blocks". You won't want to stop!

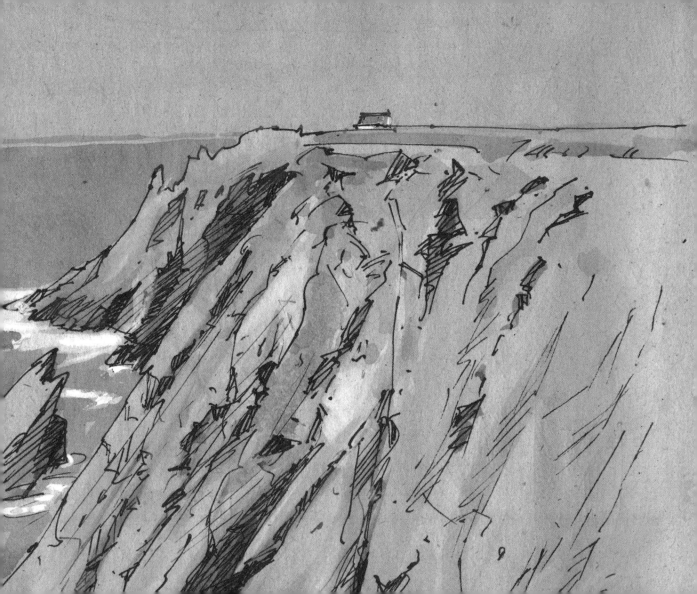

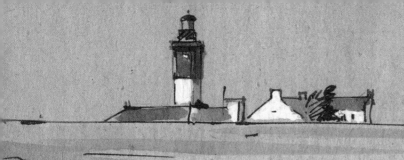

■ A WALK ALONG THE BEACH When I ask myself where I feel most comfortable as a tourist and as an artist, I have only one answer: on a rocky coast. Nowhere else can stimulate my senses quite so much as there. Clear light, the view right up to the curve of the earth, the taste of salt on my lips, patrolling seagulls in flight, their fretful cries and the slapping sounds of the water. I like to use all of it. Everything is interesting; a lot of it is difficult: the complicated forms of dancing waves and spraying mist are very difficult to capture in a drawing. Pitted cliffs eroded by salt water, beautifully smooth pebbles, silvery shiny driftwood, mussels, snails, parts of crabs, bird feathers, seaweed – unfortunately, in many places there is also a lot of rubbish washed up on the shore. My tip for a productive drawing holiday by the sea: stay in one place if possible. Small islands are ideal. Here is the island of Groix in Brittany. Within the boundaries of a manageable-sized island, there is enough to keep you busy. See also tip 77.

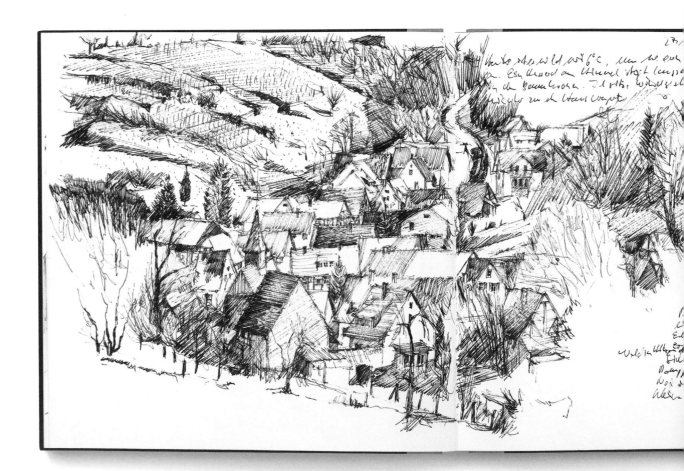

■ **FROM TWO DIMENSIONS TO THREE** The way that children start to recognise three-dimensional vision and drawing, cultivating it bit by bit, is an exciting part of their overall development. First, there's the pleasing discovery that pens make lines. Then come scribbles, which they put names to or interpret. The stage when children start to do pictographic drawings of people, animals and objects is perhaps the most delightful. To symbolise a house, a rectangle with a triangle on top is enough for a long time. Later, one or two gables will be added to the longitudinal facade.

With the onset of puberty they become good at depictions of spatial depth, using a kind of parallel perspective. It would stay like this if no help from outside were offered. Only a lesson in perspective theory can overcome this hurdle and lead to the unexpected "aha" moment. Eye level, horizon, vanishing points, lines of sight, foreshortening and central perspective are all terms used in the representational technique that gave art a tremendous boost on its discovery during the Renaissance period. Perspective visual drawing is not rocket science. A textbook, a special drawing course or hints on the internet will help. But remember the most important thing: with steady practice, theory becomes routine. See also tip 108.

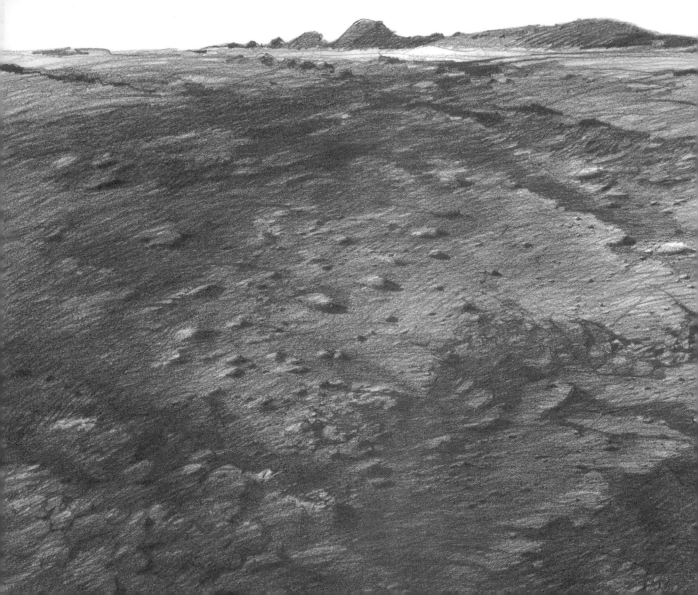

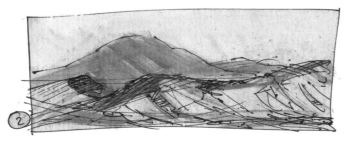

■ **DRAWING WHEN THERE'S NOTHING THERE** Landing on the island of Lanzarote is a bit like jumping off a grassy knoll onto a pile of stones. In lots of places, the island is like an over-baked loaf: dark, with jagged edges. Because of this, some tourists never come back. For others, this is precisely what they love about the island. They don't see Lanzarote as the Land of End Times.

For miles around, the magnificent mineral colours of lapilli tuffs spewed from countless volcanoes carpet the landscape. Local farmers use the black gravel in the hydroponic production of delicious wines and tasty vegetables. All around, pioneer plants push through the lava crust. The mixture of apocalyptic unreality and cultivated landscape is a real treat for artists. Soft graphite pencils, jet-black ink roller pens and felt tip pens are the perfect instruments to draw with here. They're just the right thing for these bewildering structures that demand concentration, but invite free interpretation, too.

Tempel von Kom Ombo, Ägypten 7. Februar 2015

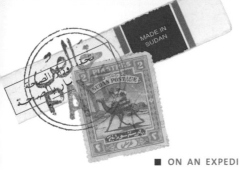

■ **ON AN EXPEDITION WITH A SKETCHBOOK** Jens Huebner's tour with bicycle and tent through the Sahara started in Egypt. The coloured drawing of the double temple at Kom Ombo comes from his diary-like sketchbook, which accompanied him on this journey. In order to capture the basic colour of the landscape, he used a highly recommended method: he used rooibos tea to colour the sketchbook paper in several places and worked with watercolours too.

Jens Hübner's drawings and watercolour paintings keep the tradition of travel painting alive; a tradition that led artists – especially in the 19th century – to areas that were largely unknown in Europe. Johann Moritz Rugendas, born in Augsburg in 1802, is mentioned here as an example. While artists of the Romantic period left in droves for Italy and Greece, he moved to South and Central America, where he created more than 6,000 works of art. These inspired the famous naturalist and world traveller Alexander von Humboldt so much that he became Rugendas mentor, patron and friend.

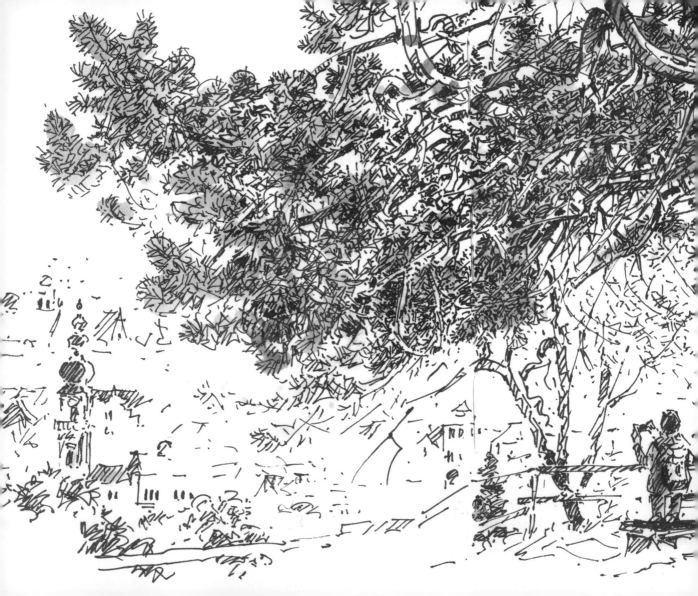

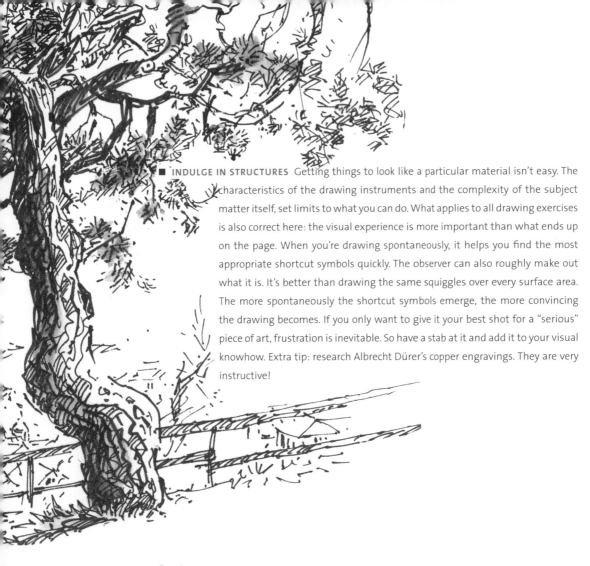

■ **INDULGE IN STRUCTURES** Getting things to look like a particular material isn't easy. The characteristics of the drawing instruments and the complexity of the subject matter itself, set limits to what you can do. What applies to all drawing exercises is also correct here: the visual experience is more important than what ends up on the page. When you're drawing spontaneously, it helps you find the most appropriate shortcut symbols quickly. The observer can also roughly make out what it is. It's better than drawing the same squiggles over every surface area. The more spontaneously the shortcut symbols emerge, the more convincing the drawing becomes. If you only want to give it your best shot for a "serious" piece of art, frustration is inevitable. So have a stab at it and add it to your visual knowhow. Extra tip: research Albrecht Dürer's copper engravings. They are very instructive!

86

16.3.2015

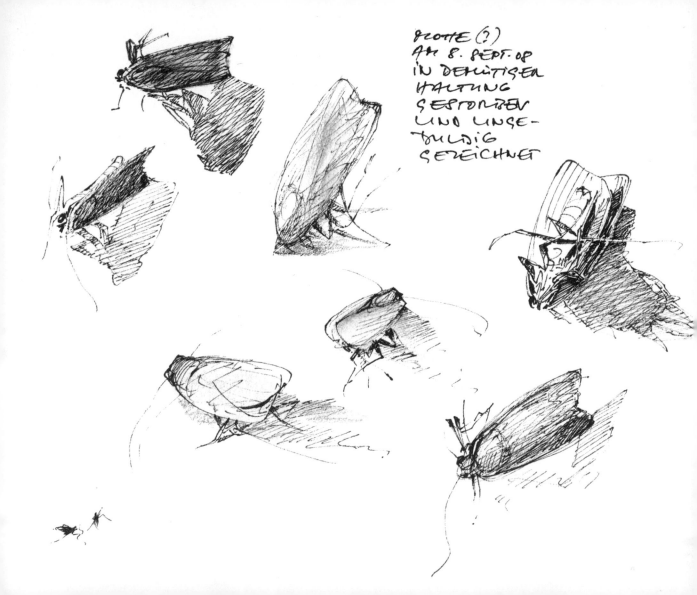

SCOTTE (?)
AM 8. SEPT. 08
IN DEMÜTIGER
HALTUNG
GESTORBEN
UND UNGE-
DULDIG
GEZEICHNET

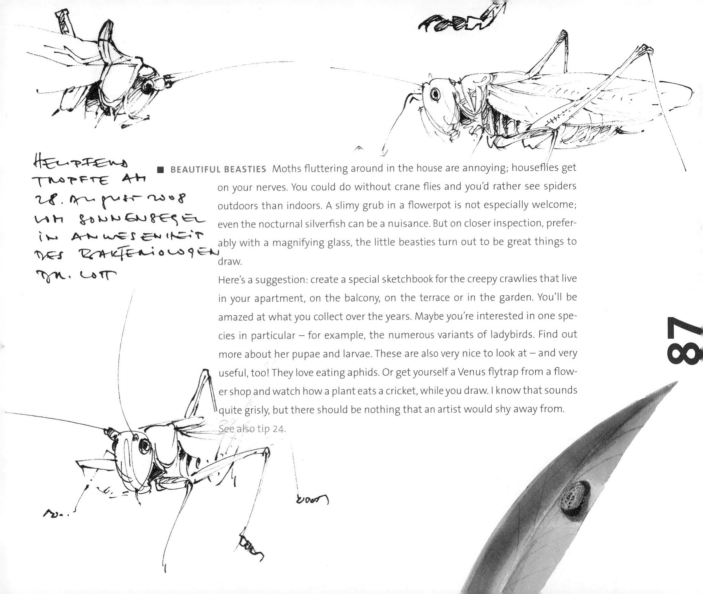

HELLGELB
TROPFTE AM
28. AUGUST 2008
UM SONNENSEGEL
IN ANWESENHEIT
DES BAKTERIOLOGEN
DR. LOTT

■ BEAUTIFUL BEASTIES Moths fluttering around in the house are annoying; houseflies get on your nerves. You could do without crane flies and you'd rather see spiders outdoors than indoors. A slimy grub in a flowerpot is not especially welcome; even the nocturnal silverfish can be a nuisance. But on closer inspection, preferably with a magnifying glass, the little beasties turn out to be great things to draw.

Here's a suggestion: create a special sketchbook for the creepy crawlies that live in your apartment, on the balcony, on the terrace or in the garden. You'll be amazed at what you collect over the years. Maybe you're interested in one species in particular – for example, the numerous variants of ladybirds. Find out more about her pupae and larvae. These are also very nice to look at – and very useful, too! They love eating aphids. Or get yourself a Venus flytrap from a flower shop and watch how a plant eats a cricket, while you draw. I know that sounds quite grisly, but there should be nothing that an artist would shy away from. See also tip 24.

87

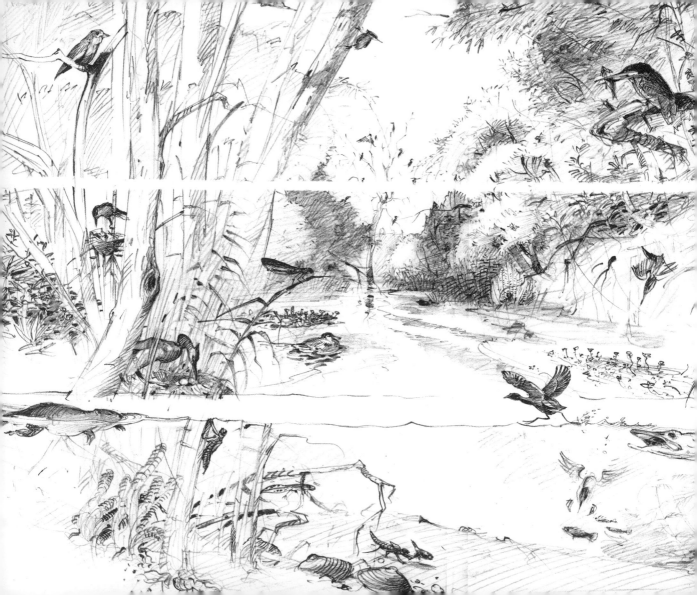

RETROSPECTIVE The 80s, the 20th century: a commission for a high-circulation magazine. The theme of the edition: the countryside around the old Rhine in storeys — above and below water. As an example: the species-rich Taubergießen wetlands on the Upper Rhine.

There was no internet, no search engines to make the research any easier. Back then, illustrators needed a comprehensive library and good relationships with zoological and botanical institutes for such a task. You were lucky if you had an atelier near a university.

The requested draft version was sent by post. The possibility of sending the final artwork to the client at the click of a mouse hadn't been invented yet. The first attempt had to be successful. If it wasn't right, the whole thing had to be done again. Photoshop didn't exist, of course.

The fact that illustrators have a natural advantage when it comes to nature studies has not changed. They know how to correctly interpret the inevitable proposals that don't provide enough information. Regardless of whether the work is done on paper or on a digital drawing board, they can trust the expertise of their own senses.

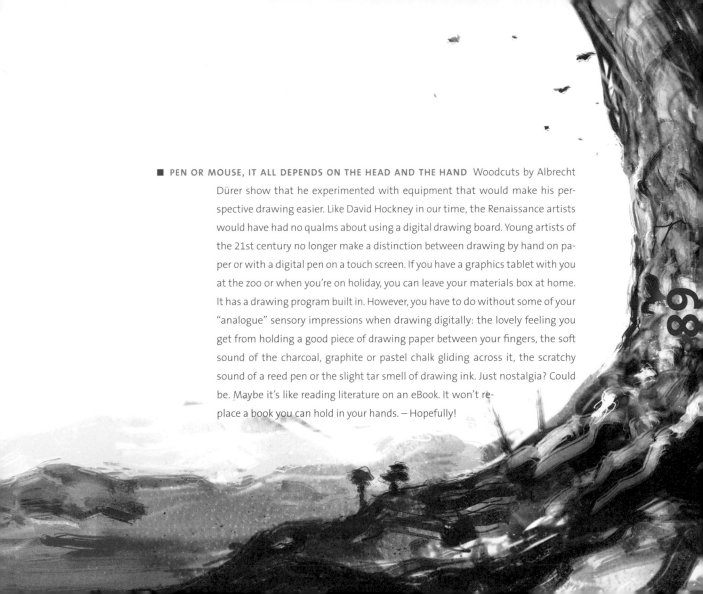

■ PEN OR MOUSE, IT ALL DEPENDS ON THE HEAD AND THE HAND Woodcuts by Albrecht Dürer show that he experimented with equipment that would make his perspective drawing easier. Like David Hockney in our time, the Renaissance artists would have had no qualms about using a digital drawing board. Young artists of the 21st century no longer make a distinction between drawing by hand on paper or with a digital pen on a touch screen. If you have a graphics tablet with you at the zoo or when you're on holiday, you can leave your materials box at home. It has a drawing program built in. However, you have to do without some of your "analogue" sensory impressions when drawing digitally: the lovely feeling you get from holding a good piece of drawing paper between your fingers, the soft sound of the charcoal, graphite or pastel chalk gliding across it, the scratchy sound of a reed pen or the slight tar smell of drawing ink. Just nostalgia? Could be. Maybe it's like reading literature on an eBook. It won't replace a book you can hold in your hands. — Hopefully!

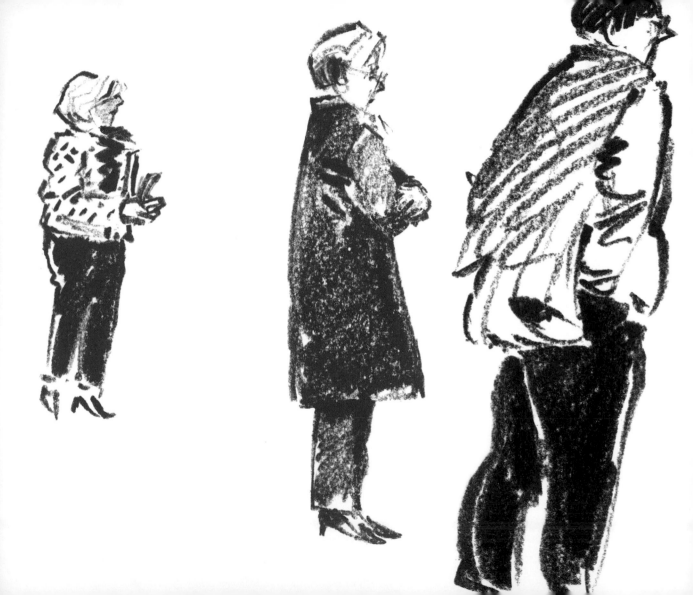

■ **ON THE SHOULDERS OF GIANTS** Sort the following artists chronologically, according to the year of their birth: Peter Paul Rubens, Leonardo da Vinci, Max Beckmann, Mary Cassatt, Giovanni Battista Tiepolo, Francisco Guardi, Jean Giraud aka Moebius, Albrecht Dürer, Käthe Kollwitz, Francesco de Goya, Hans Holbein the Younger, Rembrandt Harmenszoon van Rijn, Heinrich Kley, Max Slevogt, Wolfgang Reitherman, Katsushika Hokusai, Paul Flora, Edgar Degas, Gustave Doré, Egon Schiele, Isabel Quintanilla, Lyonel Feininger, Andrew Wyeth, Félix Valloton, Olaf Gulbransson, John Constable, Adolph von Menzel, Jean-Jacques Sempé, Henri de Toulouse-Lautrec and Horst Janssen.

Nonsense! This isn't meant seriously, of course, and it's also not the first question on a quiz show. That said, you should still take an interest in these artists' drawings. They set standards that artists can gain guidance from. The study of these, not just of masterpieces, sharpens your sense of quality and helps you to make the right decisions in your own work. Notice what excites you and what leaves you cold. See also tip 91.

GIORGIO MORANDI

HEINRICH KLEY
Leben und Werk

Betsy James Wyeth WYETH AT KUERNERS HOUGHTON MIFFLIN COMPANY

ZEROTH Bernd Küster Wilhelm M. Busch

WALTER KOSCHATZKY Die Kunst der ZEICHNUNG

AKADEMIE DER KÜNSTE CARL BLECHEN Mit Licht gezeichnet

HOKUSAI

ponisme
anges culturels entre le Japon et l'Occident

Félix Vallotton Zeichnungen SCHEIDEGGER & SPIESS

Adolph Menzel radikal real KUNSTHALLE DER HYPO-KULTURSTIFTUNG

HENRI DE TOULOUSE-LAUTREC
Herausgegeben von Rica Gautmann und Wolfgang Wittrock

Feininger Halle-Bilder Die Natur-Notizen

D LEAR The Cretan Journal

BERNSTEIN BUCH DER ZEICHNEREI

GOYA RADIERUNGEN

DUMONT

Forest Diary

ALFRED KU

GRUBER
R. SEITZ ·

GEORGE GROS

DUMONT Schnell

GRUBER, Z

44 Gulbransson · Idyllen und Katastrophen
How to draw a tree

Cole THE ARTIST
ANATOMY OF TI

129 # 2010 Randze

Weltkulturen und r

Giorgio Morandi

MENZEL SKIZ

3|0 Das Spiel mit den Bildelementen

GOLLWITZER · ZEICHENSC

JANSSEN GUARDI
HAHN LANDSCHAFTSZE

THEODOR VERHAS EDITIO
Capricorn György Doczi Die Kraft d

THE ELEMENTS OF DRAWING JOHN RUS

■ **A FEAST FOR THE EYES** The drawings by Andrew Wyeth are a revelation and are laid out in great abundance in the book, *Wyeth at Kuerners*. Still relevant today are Gerhard Gollwitzer's writings in his 1952 book, *Zeichenschule für begabte Leute* (Drawing School For Gifted People). I will never stop flicking through the pages of *Bernsteins Buch der Zeichnerei* (Bernstein's Book of Drawing). I will never forget the devout silence of the many visitors at the Berlin exhibition, featuring the wonderful works of Hokusai, and the catalogue is a feast for the eyes, too. And there's no book on the Golden Ratio that is more amazing than the richly illustrated *Die Kraft der Grenzen* (The Power of Borders) by György Doczi.

These are just a few of the books about drawing that are important to me. They have accompanied my work over the years – many of them for decades. Among them are precious, sensorial and haptic treasures to behold. Books are not fast food. They help you to learn things in context. One of the most amazing things, for example, was the fact that Adolph Menzel would draw with a carpenter's pencil. This is mentioned in the catalogue of the Munich exhibition, *radikal real* (radically real). And you can see it for yourself straight away. The illustrations are reproduced so well, it's as if you had a fax of his sketchbooks in front of you. My tip: have a rummage through a second-hand bookshop for books about artists and drawing. It's a real feast for the eyes! See also tip 90.

91

...LL IT IS OF SECONDARY IMPORTANCE IF A WORK
... A SUCCESS OR A FAILURE. IF I HAVE LEARNED TO
... LITTLE MORE ACCURATELY, I SHALL CERTAINLY
... OMETHING AND THE WORLD AROUND ME WILL HAVE
...CHED ... BECAUSE I HAVE COME TO UNDERSTAND THAT
...D IS SO FAR BEYOND MY GRASP THAT I DON'T EVEN
...ENGTH TO APPROACH IT.

GIACOMETTI

PEGGY GUGGENHEIM COLLECTION
VENICE 28. NOVEMBER 1995

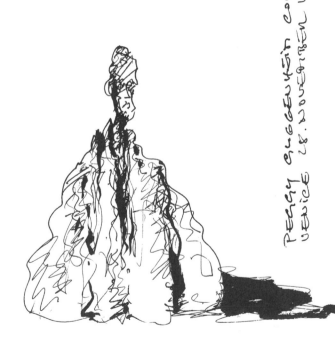

QUANTITIVE FIGURE
OF BABOON
18 DYN. 1400 BC
GOD OF WISDOM
AND WRITING

■ **MUSEUM SKETCHING** Artists stand on the shoulders of those who worked in a bygone era. The painter, graphic artist and author Oskar Kokoschka put it a similar way. For me, sketching in a museum is a fruitful exploration of this fact. I discover new or supposedly familiar things in a completely different light. For me, of course, exhibitions of artwork on paper, especially drawings that can rarely be shown because of their sensitivity to light, are particularly exciting. For the most part, this sort of exhibition leads to a burst in productivity or at least a kick in the butt: do something!

Coupled with diary-like entries and notes on the exhibits, such drawings are invaluable memory props. Furthermore: each piece of art enhances your visual memory. This stock of images helps with your own work. Give yourself plenty of time to draw in the museum. Use a sketchbook that has a hard cover you can lean on.

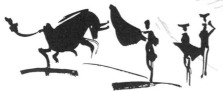

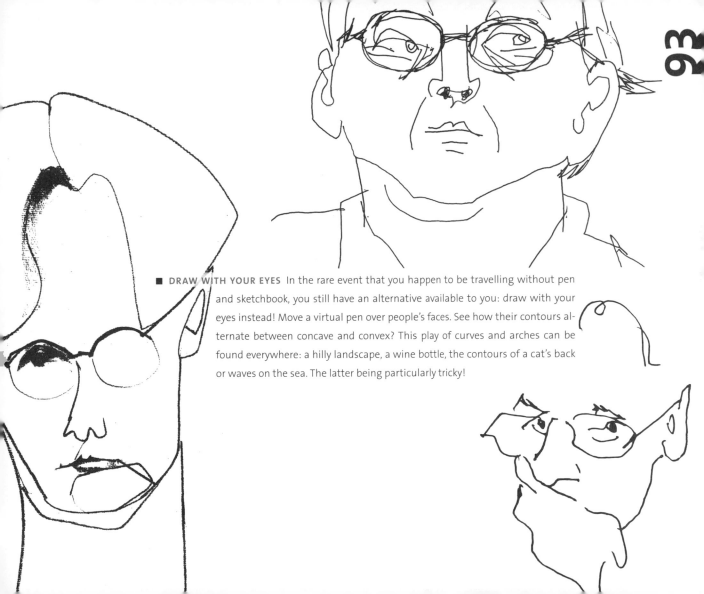

■ **DRAW WITH YOUR EYES** In the rare event that you happen to be travelling without pen and sketchbook, you still have an alternative available to you: draw with your eyes instead! Move a virtual pen over people's faces. See how their contours alternate between concave and convex? This play of curves and arches can be found everywhere: a hilly landscape, a wine bottle, the contours of a cat's back or waves on the sea. The latter being particularly tricky!

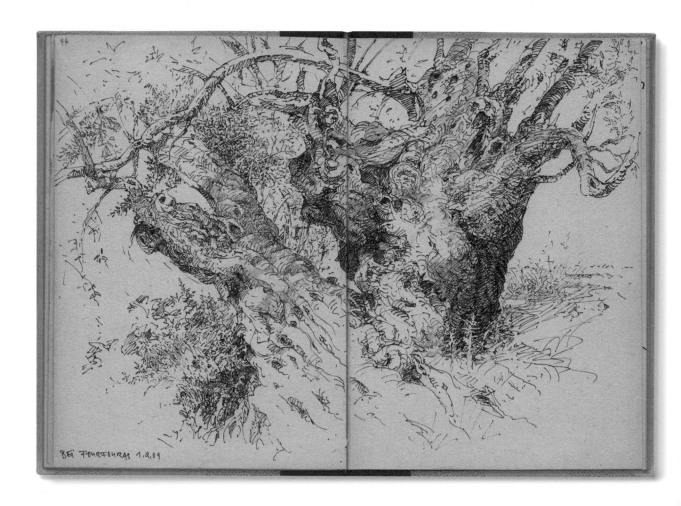

BEI FOURFOURAS 1.9.09

■ **FINDING HAPPINESS IN YOUR ENDEAVOURS** You've probably noticed a strange mixture of effort and relaxation when you draw. Despite some initial frustration, before you've managed to get the lines to "sit" properly, a state of mind that psychologists call "flow" gradually sets in. Flow describes the state of being totally absorbed in an activity that demands our concentration and effort, but which we really enjoy doing. Drawing is an excellent initiator of flow (as is making music, playing chess, climbing, jogging), because it absorbs the attention of the eye, hand and head so much that we fall into a state of self-forgetfulness and everything around us fades, sometimes for hours. After that you may be tired or even exhausted – but at the same time relaxed and satisfied. With each practice, drawing becomes more a form of contemplation and meditation that can give rise to deep feelings of happiness. Particular places also have a large part to play in this. Indulge in the flow of drawing!

56

GEFÄSSFORMEN ALS SILHOUETTE ERKENNEN UND ZEICHNEN —

POSITIV ODER NEGATIV (FREIGESTELL

■ **IDENTIFYING GAPS** A difficult chapter, especially for beginners. But not just them! We identify objects best when they are dark against a light background. What sits in between them is of little interest to our senses. Or is it? Without these spaces, the objects could not be seen. Being able to recognise them as a shape is very important for drawing and is a major hurdle in the learning process that needs to be overcome if you are to make any progress.

For example: look at the leaves of a tree. The spaces between the leaves are just as important as the shape of the leaves themselves. The spaces delineate the contours of the leaves. Those who can visualise and depict these interstices know that a drawing can get a massive boost from it. An "aha" moment that really packs a punch. You'll see the impact it has on lots of other types of subject matter, too.

See also tips 19 and 96.

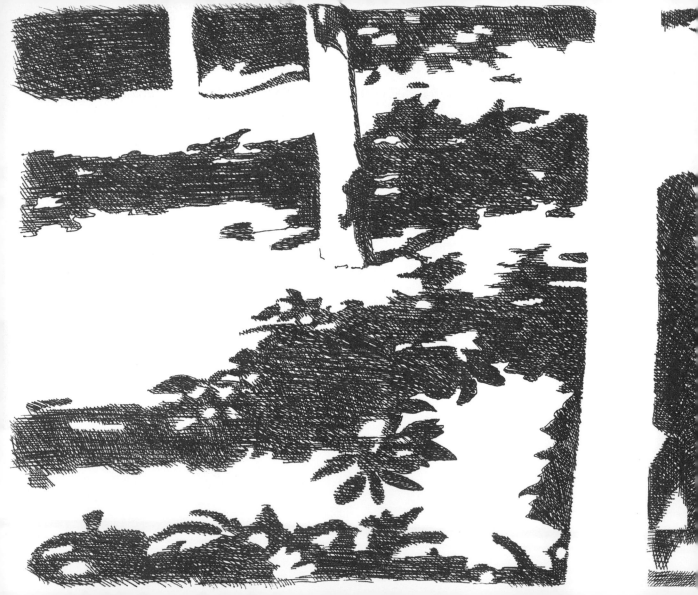

■ **INTERPLAY** You're familiar with the reversible image pictured here; perhaps other, more complicated, optical illusions that play with our perception. Do you see two profiled faces or did you notice the trophy first? Or both at the same time? If you don't find that last one difficult, then drawing an area shaded by foliage will be easy. But if you find it a little difficult, then you should start with a small section of this sort of light and shadow effect. Don't just try to see and draw the shape of the leaves. Even the flecks of light have form that must be based on the shapes of the leaves.

Sabine Baumgärtel drew this design with an ink roller pen, avoiding the edges of each surface. You can see how the tree trunks don't have to be drawn with an actual line. Our eyes are able to recognise it as a whole. Pencils or other types of drawing instruments are also good for this exceptionally useful exercise. If you are satisfied with the result, take a piece of black card and mark the light patches with a white pencil crayon. Very enlightening! See also tips 19 and 95.

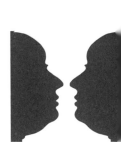

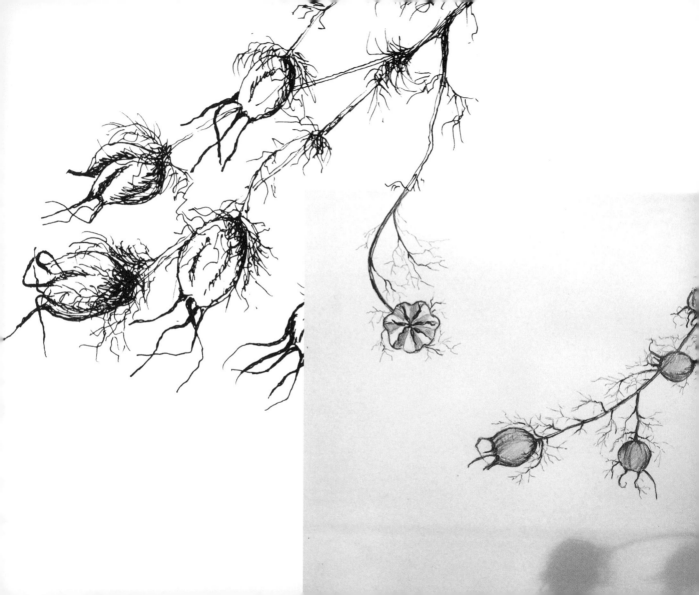

■ **PAPER AS A LIGHTSPACE** A piece of drawing paper doesn't just provide the background for the subject matter. It is part of the composition and the space in which your artwork should have optimal place. If a drawing is simply placed in the middle of the page, it can't enter into an exciting relationship with the overall surface. The picture on the left demonstrates how a sheet of drawing paper can really become a three-dimensional space. At first, only the drawing was visible. Then, illuminated by a lamp, a real leaf was placed on the drawing so that its shadow could be reproduced on the paper. Using a camera, both were captured together. This demonstration shows how to magically transform a piece of paper into a three-dimensional lightspace. The other drawing, the one without a shadow, doesn't have that quality. So whenever you get the opportunity, try adding shadows to your drawings. This not only creates space, but generates light too. The presence of shadows creates atmosphere — a factor that is essential in terms of the artwork being accepted.

See also tip 98.

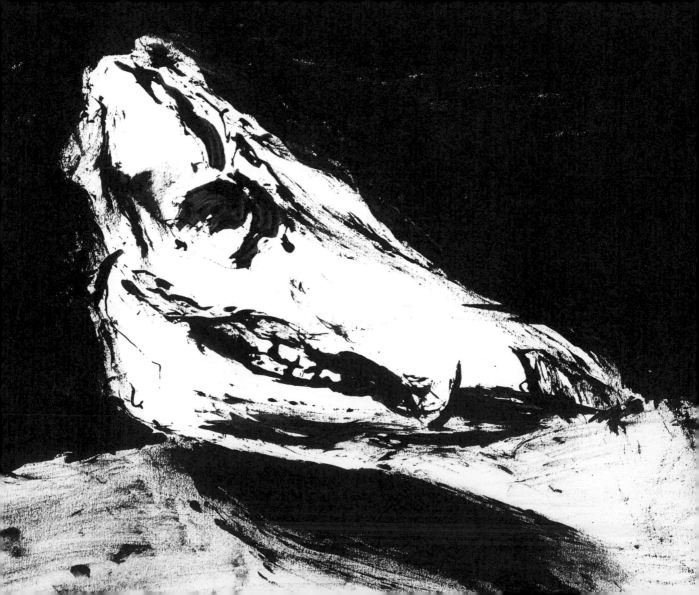

■ **CAST A SHADOW** Shadows switch on the light. In a drawing, you can do things that make no sense in the physical world. The darker you draw the areas around the white sections, the lighter they will look against the paper. Here you can see the effect of shadows being cast. Unlike self shadows and cast shadows, they are more or less separated from the subject. The drawing on the left demonstrates how three-dimensional space can be created, just through the use of shadow on a flat piece of paper. On the left, the stone casts a shadow on a painted surface. Here on this page, it turns the white paper into its own lightspace. Without the shadow, the pebble would look like it had been glued onto the page. You can test this by covering the shadow with a piece of white paper.

See also tip 97.

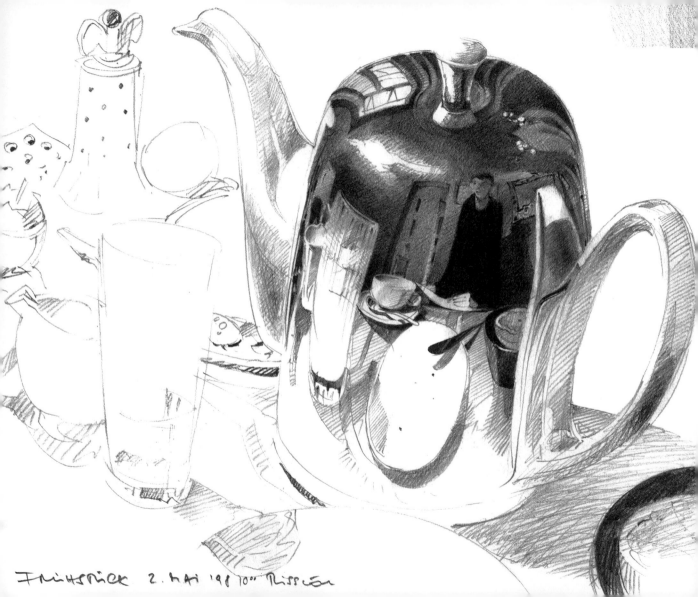

FRÜHSTÜCK 2. MAI '98 10" Rissen

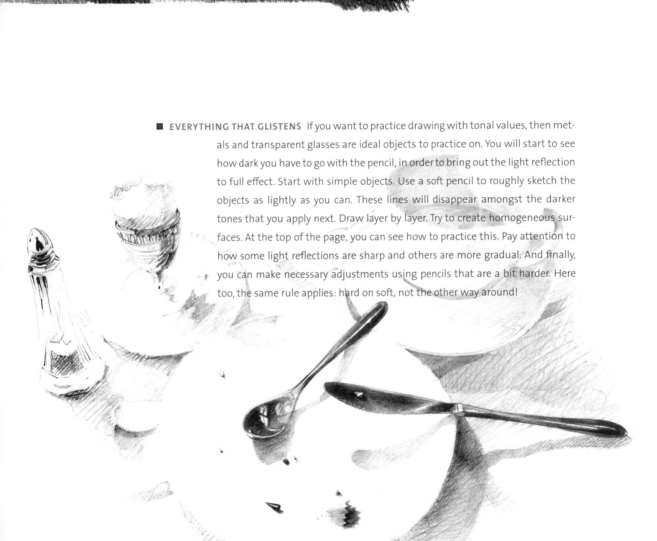

■ **EVERYTHING THAT GLISTENS** If you want to practice drawing with tonal values, then metals and transparent glasses are ideal objects to practice on. You will start to see how dark you have to go with the pencil, in order to bring out the light reflection to full effect. Start with simple objects. Use a soft pencil to roughly sketch the objects as lightly as you can. These lines will disappear amongst the darker tones that you apply next. Draw layer by layer. Try to create homogeneous surfaces. At the top of the page, you can see how to practice this. Pay attention to how some light reflections are sharp and others are more gradual. And finally, you can make necessary adjustments using pencils that are a bit harder. Here too, the same rule applies: hard on soft, not the other way around!

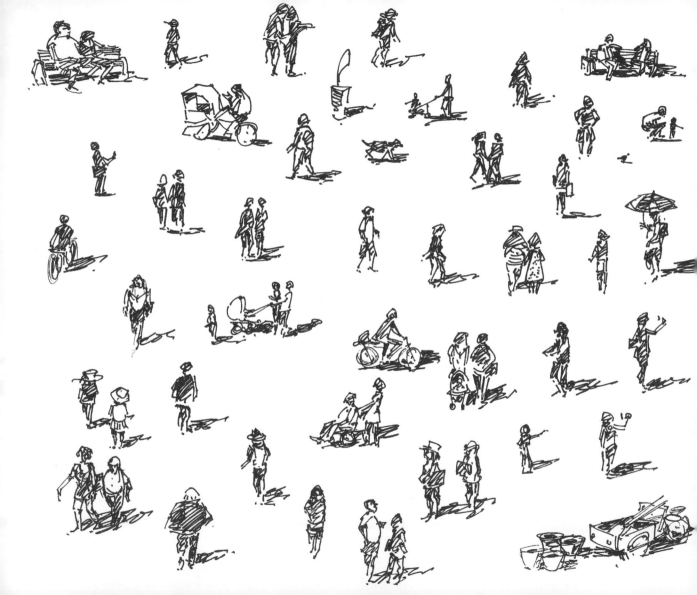

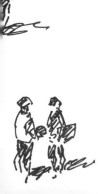

■ **IS EVERYTHING ALRIGHT? NOT AT ALL!** "And no matter how clumsily or badly drawn a thing may be, no matter what, I want to see volition in every line, that is everything, correctness is nothing." With these oratorical lines, Arnold Böcklin (1827-1901) states a clear preference for this over making an accurate copy of the subject.

Being able to reproduce the subject matter with anatomical accuracy, or accurate perspective, doesn't necessarily equate to it being a good piece of artwork. Drawings by Pablo Picasso are an eloquent example of this. His genius is grounded in the enthralling strokes of his brush, free from the shackles of expected accuracy, which nevertheless articulate exquisite powers of observation. This is where the fascination in his drawings lies. Such carefree expression cannot be achieved overnight. But there are some useful shortcuts.

See also tips 47 and 111.

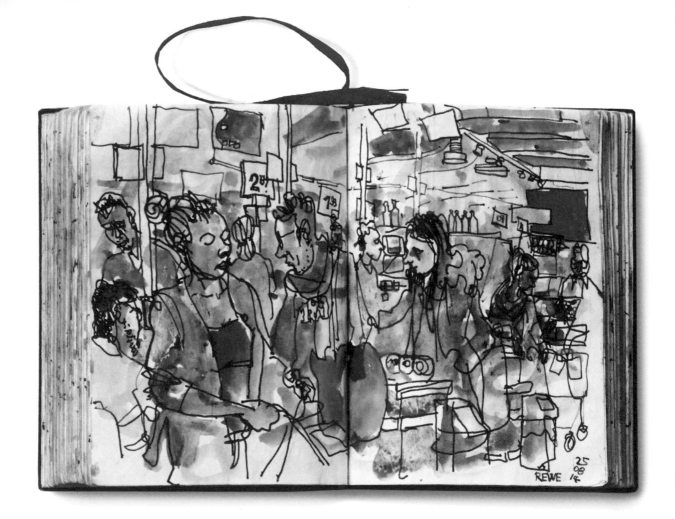

REWE
25
08
18

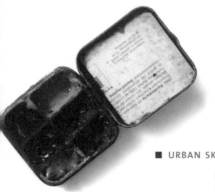

■ **URBAN SKETCHING** Founded in 2007 in Seattle, the Urban Sketchers organisation has grown into a worldwide movement. Groups have formed in many different cities, where people arrange a time and place to draw together. Their artwork isn't presented in museums and galleries, but on the internet instead.

Here's an excerpt from their mission statement: "We draw on location, indoors or out, capturing what we see from direct observation. Our drawings tell the story of our surroundings, the places we live and where we travel. Our drawings are a record of time and place."

Search for Urban Sketchers on the internet. You'll be amazed by how many techniques and styles you'll discover! On their website, you will also find information about local groups. Maybe you fancy joining in? Among the Sketchers are some real experts. The drawing on the left is by Berliner Rolf Schröter. You're probably thinking, "It's pretty brave to draw in a supermarket". Yes, it is. But over time you get used to drawing in busy places and focusing on the subject.

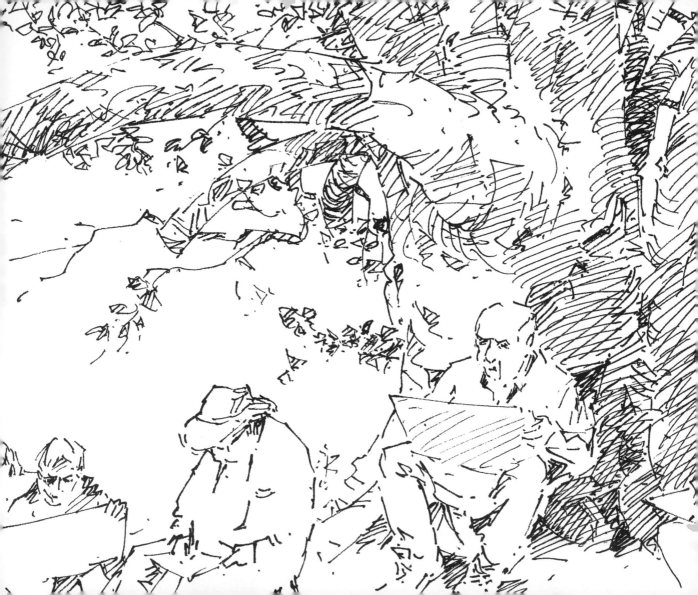

■ **COMPETITION ANIMATES** From a group dynamics perspective, drawing groups are pretty interesting. Along with all the different kinds of personalities, there are always individual participants who anxiously block themselves because they believe that there could be someone who is "better" than them.

Here are a few considerations that might help. Turn this concern into an active interest in what others are doing. Criticise others constructively and allow others to criticise you. You can always learn something from others. Believe in your ability to improve your work. Don't expect to make progress overnight. Learning how to draw requires time.

Urban Sketchers, the worldwide movement of artists who meet up regularly and publish online, know what a positive effect drawing in groups can have.

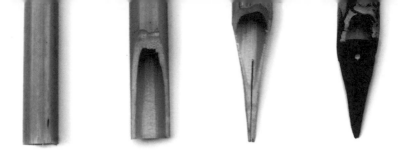

■ **AS STIFF AS A STICK AND UNPREDICTABLE** It hardly holds any ink, it scratches, splashes and drips... but it's still fantastic to draw with. The reed pen needs a hand that can make bold strokes over the paper. You have to be brave! A tool for artists who don't shy away from risk and who know that something could indeed go wrong. Traditionally, reed pens are made from bamboo. You can buy a perfectly made reed pen at an art supplies shop. But making one yourself is a lot of fun. You'll need a pipe that is as thick as your finger and some skill in using sharp knives. The advantage of self-made reed pens is that each one is different. You can make one with a pointed tip and have another with the end left flat. It's important that the front of the reed is carved very thin and is cut lengthways so that it is divided in the middle. This makes it more bendy and springy. Drill a hole at the end of the cut. This helps to keep the ink on the smooth bamboo wood for as long as possible. Since the ink can make the wood seal up, you should wet wipe the bamboo nib after use.

■ **DRAWING MAKES YOU HAPPY** Danny Scholz likes to draw portraits on small boards and large canvases. Here we see the artist himself, standing next to his work, satisfied and proud. It's easy to see it is a self-portrait. His pictures are admired in exhibitions and sought after by collectors.

But luck wasn't always on his side. Danny Scholz has limited motor skills. He is a member of Atelierblau in Worms, Germany. Taking part in art workshops at the Lebenshilfe organisation has a huge positive effect on the disabled artists there.

Danny Scholz draws pictures that convey strong, evocative impact. They come across as authentic, unaffected by genres. His works are created intuitively "from the gut". Free of conventions, Danny Scholz's art is an invitation to think about how image effects come about and what authentic drawing means. His art is inspirational and inimitable. So my tip is: always look for an opportunity and exercises that will help to portray a theme as expressively as possible. See also tip 37.

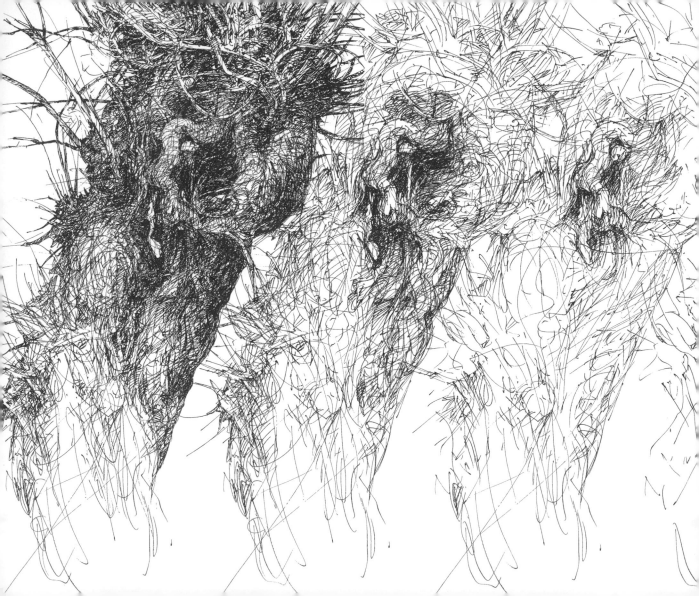

■ **STEP UP** You can create wonderful three-dimensional effects just by drawing lines. The denser you draw them, the brighter the parts that need to stand out will appear. You can achieve very dark tonal values quickly with parallel hatching. Structuring the details of something – bark, for example – depicts its specific texture. Using shortcut sketches that help to densify or soften a surface gives you more control over the tonal values. Parallel hatching and structuring work well together, too.

Take photos of structures found in nature and make a collection to refer to later. Black and white shots are best for this purpose. This fine-tunes your perception and helps you to draw from direct observation. I advise against drawing from these photos, though. It is far more instructive to draw from three-dimensional objects in front of you. See also tips 28, 29 and 74.

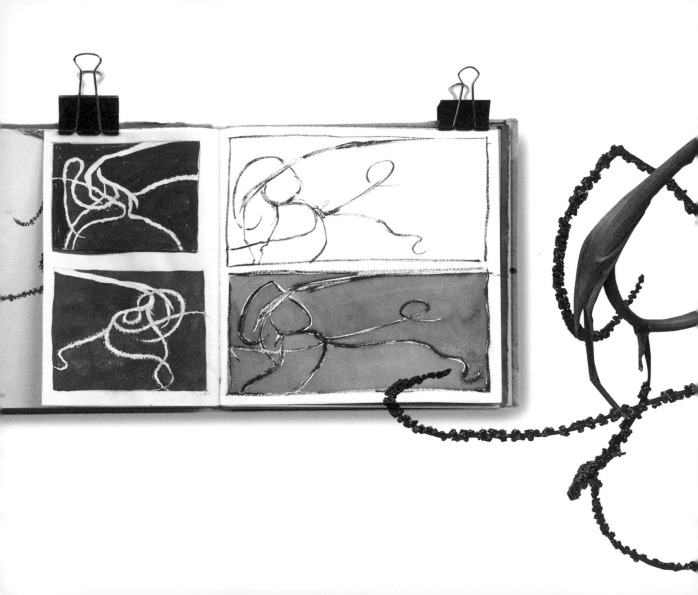

■ JUST BECAUSE The strangely shaped structure highlighted here is the inflorescence of a parlour palm. Five stems hang from one of its stalks, like the tentacles of an octopus: a beautiful object, for a patient artist. If that describes you, you'll be commended for how perfectly you can reproduce it. Scientific illustrators need this sort of temperament. That too can be great art.

But if you are one of the more impatient kind, consider this sort of shape as an invitation to give your hand free rein. Place the object on your drawing paper to create an intriguing composition. After a while, you won't see the object anymore, you'll forget what it is. Distort how it looks by using colour. Vary its shape. Use different drawing techniques. Combine these with acrylics, tempera and watercolours or other materials. There are no limits to what you can do with these experiments. You can spend a lot of time on this and even fill a whole sketchbook. Katja Rosenberg bound the book pictured here herself.

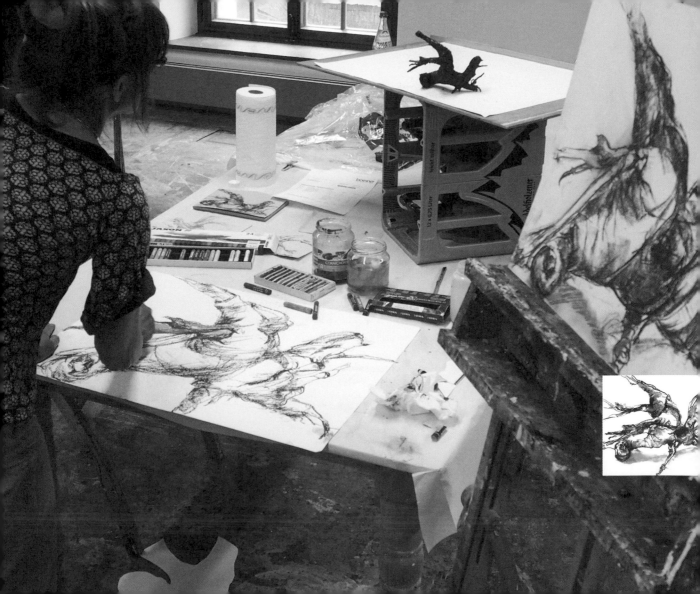

■ **GET TO THE ROOT OF IT!** Using a pencil, ink roller pen, red chalk, crayons, watercolours, pastel crayons, acrylics or charcoal on coloured paper or paper that has been painted beforehand; watercolours on hand-made paper, in a sketchbook over the binding, across the large arch of the easel, smudged with your finger, washed, etched, hatching to create texture or form, sprayed, copy printed, the object from the back, from the front, seen from above or below, at eye level, turned round, turned upside down, diagonal, falling in on itself, harmoniously inside the golden ratio, cut, centred, pinched, sandwiched between, with and without shadow, in negative, illuminated, meticulously, like Dürer, surreal, expressive, naturalistic, abstract, distorted... and all that is talking about the same object. You'll be amazed at the ideas you'll come up with! Don't have a root to hand? That's no excuse! See also tip 7.

■ **A REQUEST** "A primary school's main priority is to support each child individually." This is roughly what is written in the German state curriculum. Art lessons should nurture visual thinking, enable children to discover their capacity for perception and expression, and lead to the development of an autonomous visual vocabulary. But how can they develop a visual vocabulary of their own when some schools don't even have enough books to give out, where children – during their most creative phase, no less – are given things to colour in and only have a choice of a few colours? My request: if you work with children or have the opportunity to draw with them, encourage their creative abilities with tasks that suit their age and interests. Bring out the creative talents that lie dormant in every child. You won't believe your eyes! See also tip 83.

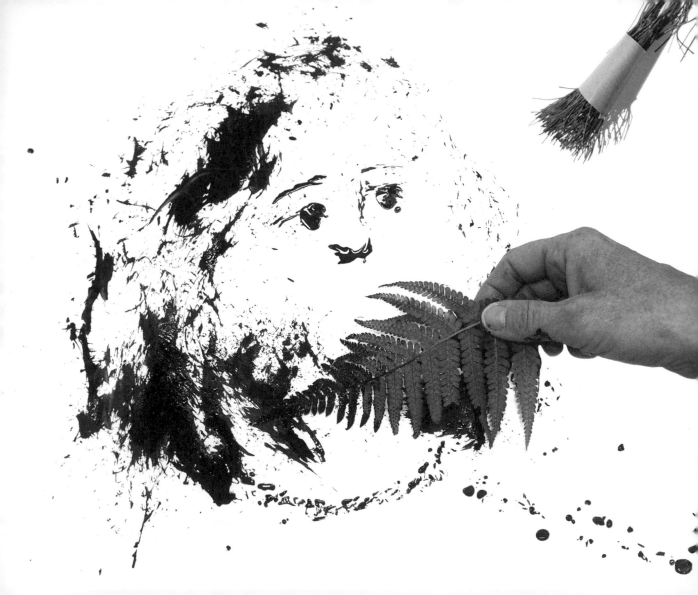

■ **OUT OF CONTROL** Are you dissatisfied with your usual drawing style, or do you think your drawings look stiff and lack spontaneity? A radical change of technique could work wonders. Maybe just playing around with unfamiliar material sometimes is enough to shake things up. It's quite possible that this sort of experimentation will help to broaden your drawing capabilities. Explore everything that can be understood by the term *drawing*.

Try taking control away from the brain and the hand. Experiment with it. Keep all available materials within reach. You'll be amazed at what ideas you come up with and what surprises you experience. I guarantee you'll have wonderful flow. You will forget the world around you. See also tip 75.

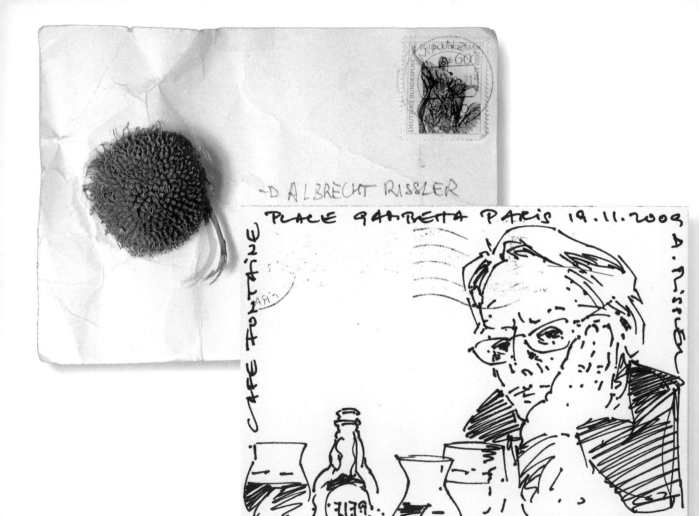

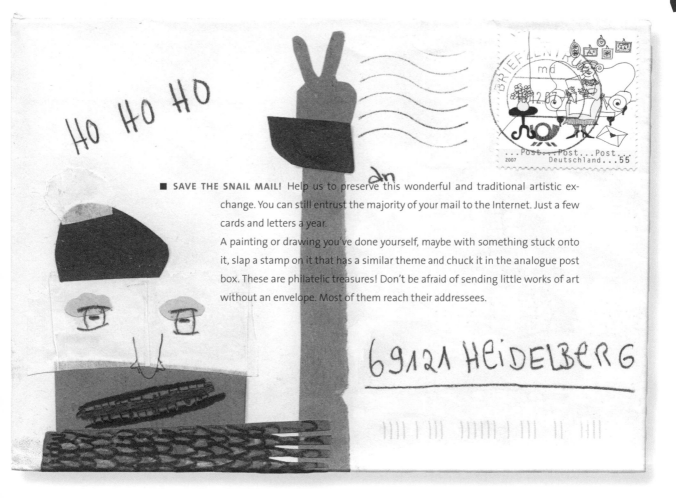

HO HO HO

■ SAVE THE SNAIL MAIL! Help us to preserve this wonderful and traditional artistic exchange. You can still entrust the majority of your mail to the Internet. Just a few cards and letters a year.

A painting or drawing you've done yourself, maybe with something stuck onto it, slap a stamp on it that has a similar theme and chuck it in the analogue post box. These are philatelic treasures! Don't be afraid of sending little works of art without an envelope. Most of them reach their addressees.

69121 HEIDELBERG

...Post...Post...Post...
2007 Deutschland...55

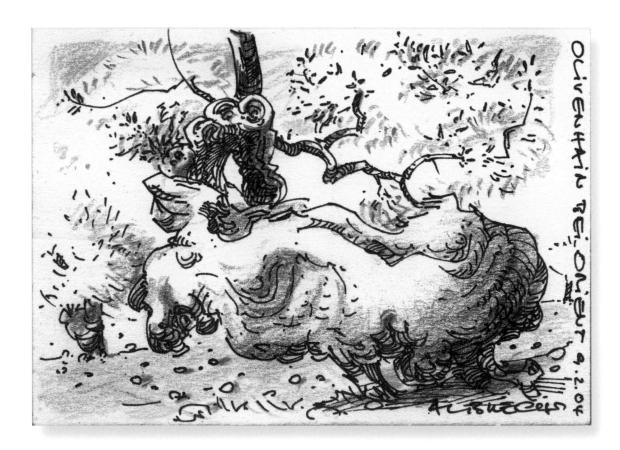

■ **MAKE PICTURES, NOT COPIES!** When drawing nature outdoors, it's understandable that you want to make an "accurate" depiction. But try as you might, you'll never succeed in rendering it exactly. However, the complexities of natural form — along with the limitations of the drawing materials themselves — necessitate abstraction. And that's a good thing.

Don't make yourself a slave to the subject matter. You design it, as you see fit. You can omit certain details completely, invent others, simplify them considerably, hint at them sparingly, pull them together or tear them apart. Do what you think optimises the overall effect of the image. Knowledge of compositional possibilities will help. You immediately get the feel of whether the image layout works or not and this contributes to the quality of the final artwork. Even those who are not familiar with design issues will intuitively pick up on what you were trying to express. See also tips 47 and 100.

111

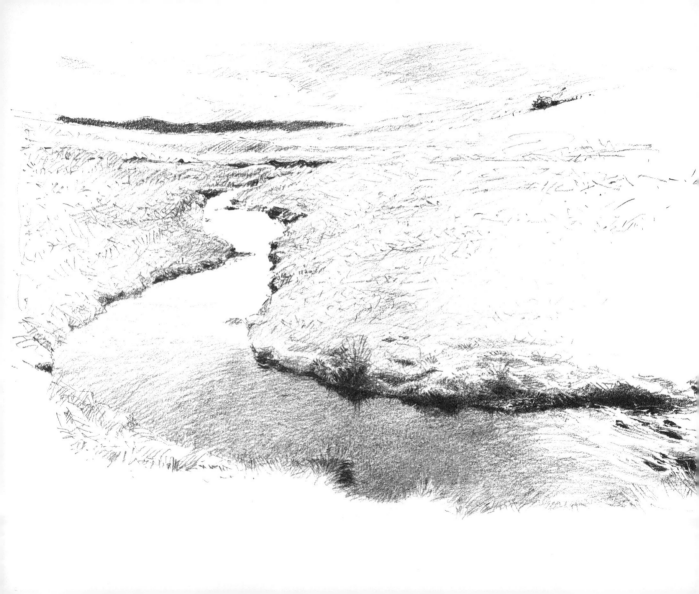

■ **WHEN IS A PICTURE FINISHED?** This question will preoccupy you the whole time you draw. The artwork on this page demonstrates how many tonal values are required to achieve a specific effect. With this stream in Scotland, I wanted to bring the backlight on the surface of the water to full effect. As you can see, just a few tones are enough to achieve this effect. But how do you learn to stop at the right moment? It's understandable to be scared of spoiling a drawing. But sometimes it's worth it to overshoot the target. This way, you gain important experience of how you can gauge between stopping too early and spoiling a piece of work. It will give you a sense of when to put the pen down. Take photos to document each stage. That makes it clear.

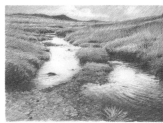

START!

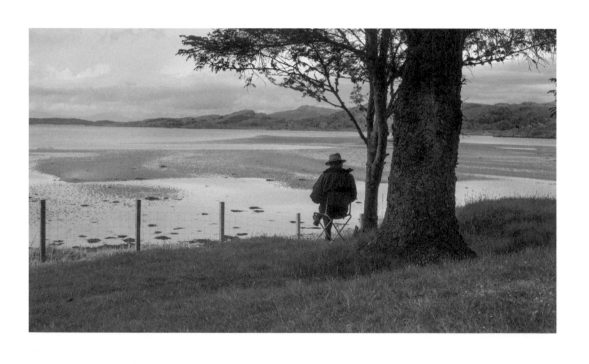

■ **ALBRECHT RISSLER** Born in 1944. Trained as a decorator, worked as a poster artist. 1963 First solo exhibition with small-scale sculptures, drawings and paintings. 1966 The beginning of a second educational path, culminating in a degree course to become a teacher of arts and crafts. Lecturer of painting and printing techniques. 1981 Moved into the teaching profession, founded an illustration workshop and entered into a long-term collaboration with the environmental magazine "Nature", published by Horst Stern. 1987 Held a lectureship at the University of Applied Art, Design and Media, Stuttgart. 1988 Appointed Professor of Drawing and Illustration in the Design Department at the University of Applied Sciences, Mainz. 1995 Publication of the book, "Zeichnen, unterwegs mit Stift und Skizzenbuch" (*"Drawing, In Route With a Pen and Sketchpad"*) by Callwey publishing house, Munich. Since 2002, drawing courses in Irsee, Oppenheim, Bad Reichenhall, Ladenburg, Rangendingen and Heidelberg. 2012 Publication of the book "Zeichnen in der Natur" (*"Drawing in Nature"*) (Edition Michael Fischer, Munich). This was followed by the books "Komposition, die Kunst der Bildgestaltung, eine Sehschule nicht nur für Fotografen" (*"Composition, the Art of Image Design, a Sight-Training School That's Not Just for Photographers"*) (2014), "Zeichen Tipps für Kreative" (2015) (*"Creative Drawing"*, 2019, Hoaki Books), the new edition of "Zeichnen unterwegs mit Stift und Skizzenbuch" (*"Drawing, En Route With a Pen and Sketchpad"*) (2016) and "Farbgestaltung Fotografie" (*"Use of Colour in Photography"*) (2017) at dpunkt.verlag in Heidelberg.

tre: Hans Dorenburg **63** Christian Barthold, http://cargocollective.com/Christian-Barthold **65** Jörg Hülsmann, www.joerg huelsmann.de **68** Christian Felder, www.christianfelder. de **69** Right page: Dr. Alfred Görstner, www.malereigrafik. goerstner.de **70** Prof. Eberhard Linke, www.stiftunglinke.de **71** Mandy Schlundt, www.mandysbilder.de **75** Katja Rosenberg **81** Right page: Waltraud Kissinger **83** Left page: Martin Stankewitz, right page: Barbara **85** Jens Hübner www.jenshuebner.de **88** Right page, centre: Angelika Konopatzki **89** Raimund Frey, www.raimundfrey.de **93** Left to right: Rupert Lehmann, Julia, Susann Stoebe, www.motivwerkstatt.de, Andrea Keller, Emilie Vanvolsem, www.emilievanvolsem. info, Lutz Heyder **96** Left page: Sabine Baumgärtel, right page, top: Lena Ramdohr **97** Left, top: Josef Haug, www.josefhaug.de, centre: Richard Franke, top right: Agathe Haslach **98** Left page: Andrea Diemer **101** Sketchbook and Photos: Rolf Schröter, skizzenblog.rolfschroeter.com **104** Danny Scholz, www.atelier-blau.com **106** Katja Rosenberg **107** Annette Böhmer **108** Julia **109** Andrea Diemer **110** Outside left: Stefan Gelberg, right page: Anabel Leiner, www.anabelleiner.de **111** Photo: Ursula RückaufRissler, inside cover photo: Thomas Weil, Photo Vita: Walter Spagerer, all other drawings and photos by the author.

> OUR BOOKS ON DRAWING AND PAINTING <

EXPLORING BLACK & WHITE
Drawing and Painting
Techniques

Víctor Escandell

ISBN 978-84-16851-82-9
19.30 x 26.10 cm
128 pages

EXPLORING HYPERREALISM
Drawing and Painting
Techniques

Martí Cormand

ISBN 978-84-16851-84-3
19.30 x 26.10 cm
128 pages

EXPLORING COLLAGE
AND MIXED MEDIA
TECHNIQUES

Víctor Escandell

ISBN 978-84-17412-46-3
21.00 x 25.50 cm
128 pages

LEARN TO SEE
LEARN TO DRAW
The Definitive and Original
Method for Picking Up
Drawing Skills

David Köder

ISBN 978-84-17656-09-6
22.30 x 22.60 cm
208 pages

**DRAWING
THE HUMAN HEAD
Anatomy, Expressions,
Emotions and Feelings**

Giovanni Colombo,
Giuseppe Vigliotti

ISBN 978-84-16851-02-7
21.80 x 30.30 cm
192 pages

**PORTRAYING CHILDREN
Expressions, Proportions,
Drawing and Painting
Techniques**

Daniela Brambilla

ISBN 978-84-16851-55-3
21.80 x 30.30 cm
208 pages

**HUMAN FIGURE DRAWING
Drawing Gestures,
Postures and Movements**

Daniela Brambilla

ISBN 978-84-15967-34-0
21.50 x 29.70 cm
256 pages

**A WATERCOLOUR A DAY
365 Tips and Ideas for
Improving your Skills
and Creativity**

Oscar Asensio (ed.)

ISBN 978-84-16504-89-3
20.30 x 25.30 cm
176 pages

See our full collection of books at **www.hoaki.com**

HOAKI

Hoaki Books, S.L.
C/ Ausiàs March, 128
08013 Barcelona, Spain
T. 0034 935 952 283
F. 0034 932 654 883
info@hoakibooks.com
www.hoaki.com

Creative Drawing
100 Tips for Expand your Talent

ISBN: 978-84-17656-11-9
D.L.: 14489-2019
Printed in China

Copyright © 2015 by dpunkt.verlag Gmbh, Heidelberg, Germany
Title of the German original: *Zeichnen – Tipps für Kreative*
ISBN: 978-3-86490-239-0
Copyright © 2019 by Hoaki for the English edition
All rights reserved

English translation: Emma Sayers
Editing: Gerhard Rossbach, Barbara Lauer; Copy-editing:
Susanne Rudi; Design: Albrecht Rissler; Production:
Birgit Bäuerlein; Front cover image: Rupert Lehmann;
Back cover: images from the book